I do not doubt but the majesty & beauty of the world are latent in any iota of the world . . .

I do not doubt there is far more in trivialities, insects, vulgar persons, slaves, dwarfs, weeds, rejected refuse, than I have supposed . . .

I do not doubt interiors have their interiors, and exteriors have their exteriors— and that the eye-sight has another eye-sight, & the hearing another hearing, and the voice another voice.

— Walt Whitman

Walker Evans

With an introduction by

John Szarkowski

The Museum of Modern Art, New York

Distributed by New York Graphic Society Ltd., Greenwich, Connecticut

© Copyright 1971, The Museum of Modern Art
11 West 53 Street, New York, New York 10019
Library of Congress Catalogue Card Number: 71-146835
Cloth Binding ISBN 0-87070-312-9
Paperbound ISBN 0-87070-313-7
Type set by Boro Typographers, Inc., New York
Printed by Rapoport Printing Corp., New York
Bound by Sendor Bindery, Inc., New York
Designed by Carl Laanes

Acknowledgments

ON BEHALF of the Museum, I would like to thank Walker Evans for his generous, patient, and immensely valuable cooperation in the preparation of this book and the exhibition it accompanies, and for the loan of many works from his own collection. Other works included here or in the exhibition are from the Museum's collection, and include the gifts of Mrs. Douglas Auchincloss, Mr. and Mrs. Alfred H. Barr, Jr., Lincoln Kirstein, Mrs. Bliss Parkinson, Mr. and Mrs. John Spencer, and Willard Van Dyke, and other works acquired by purchase.

The Museum is indebted to the New York State Council on the Arts for granting funds which allowed Mr. Evans the time and assistance to retrieve, print, and review a large body of work which existed only as negatives. The importance of bringing this work to light was recognized by Henry Allen Moe, who lent his enthusiastic support to the retrieval project. Important assistance was also provided by Arthur Bullowa and other friends of the Museum. The new prints resulting from this project were made by James Dow and Charles Rodemeyer. Mr. Dow has also provided invaluable assistance with preliminary picture research.

Special thanks are due the Library of Congress, and Edgar Breitenbach and Alan Fern of its Prints and Photographs division, for the loan of negatives from the Farm Security Administration Collection so that these might be printed under Mr. Evans' supervision. Prints made from these negatives appear on pages 79, 81, 85, 86, 87, 91, 95, 97, 100, 101, 103, 107, 111, 113, 116, 117, 119, 121, 124, 125, 141, 143, 146, and 147. The portraits of Hart Crane, Lincoln Kirstein, Ben Shahn, and James Agee on pages 12 and 13 are by Mr. Evans.

For counsel, encouragement, and valued criticism, I would like to express my deep appreciation to Lincoln Kirstein, James Thrall Soby, Helen Franc, and Leslie Katz. This book however does not presume to reflect their own views; nor does this acknowledgment of debt implicate them in the book's failings.

Finally, I would like to thank Harriet Schoenholz for her tolerance as editor of the book's text.　—J.S.

Contents

Introduction

WALKER EVANS made his first serious photographs in 1928, at the age of twenty-four. His attempt to become a photographer seems to have been almost a willful act of protest against a polite society in which young men did what was expected of them. His own background and education would seem more likely to have produced a broker, or a publisher, or perhaps an advertising executive, which his father had been.

Evans was brought up in the proper Chicago suburb of Kenilworth, where he enjoyed the temporal comforts allowed by modest affluence, and learned to play a moderately competent game of golf. When his parents separated he moved to New York with his mother, and continued his education at Loomis, Andover, and Williams. He enjoyed Andover; there he discovered literature and first entertained the idea of being a writer himself. He found Williams no challenge. After a year of free and wide-ranging reading in the library he dropped out and returned to New York, where he lived with his mother and worked as a night attendant in the map room of the Public Library. In 1926 he went to Paris, where he was an auditor at the Sorbonne. He also read Flaubert and Baudelaire, saw the paintings of the School of Paris, and visited Sylvia Beach's bookshop, where he occasionally saw—but never dared speak to—James Joyce.

When Evans returned to the United States in 1927 he found himself out of sympathy with the aims and the style of the American establishment. He resented both the American's preoccupation with money and the fact that he had none of his own. He resented the smug self-satisfaction of a nation dedicated to business, and its tolerant lack of interest in his own literary and artistic concerns. Doubtless he also resented his own anonymity. In broad outline he was perhaps a conventional, if well-groomed, bohemian.

In 1928 he acquired a vest-pocket camera, and decided, almost arbitrarily, and out of a frustration fed by a series of formless and temporary jobs, to become a photographer. He had only a modest knowledge of,

and a very limited respect for, the medium's achievements. His immense respect for good writing had on the other hand effectively blocked his literary ambitions. Photography was something he thought he could do, and something that he would make intellectually estimable.

If Evans was in some ways a conventional bohemian, he was also a young man of high ambition. He began as a photographer by challenging in his own mind the two most conspicuously successful figures in the field: Alfred Stieglitz and Edward Steichen. As it then seemed to Evans, Stieglitz was deplorable for his artiness, and Steichen for his commercialism: each sin a matter of paying homage to values other than the free exploration of the truth. These judgments were unfair, as Evans later understood and admitted; nevertheless they served the purpose of clarifying the options that remained open for Evans, and of supplying the energy that comes with belligerence.

After the crash of 1929, resisting the temptation of commercialism was not difficult. In 1931 Evans did one or two advertising assignments, hated them, and refused to pursue the matter. The question of artiness was a more subtle issue. The term is an artist's rather than a critic's word, and its meaning is generally expressed by the inflection of the voice. One might however hazard a tentative definition: artiness refers to an exaggerated concern for the autographic nature of a personal style.

In spite of misgivings, Evans in 1929 did visit An American Place to show his work to Stieglitz. The visit had been instigated by an acquaintance of Evans, in the conventional hope that the blessings of the old man might somehow advance the career of the young one. Evans remembers Stieglitz as tired and preoccupied, and his attention to the pictures as dutiful. When he had looked at the last print he rose, sighed, and said that the work was promising, and that Evans should continue photographing. Evans made a proper response, and left. During the remaining sixteen years of Stieglitz's life, the two did not meet again or correspond, nor is there evidence that Stieglitz again took cognizance of Evans' work.

The meeting was not a success. Nevertheless, considering the perspectives (and the egos) of the two principals, it is to their credit that the occasion was polite if not productive.

In 1929 Stieglitz was at the height of his powers as an artist, and at the height of his influence as a prophet and philosopher. Harold Clurman wrote later that Stieglitz's work "at this time becomes virtually majestic not only by an unsurpassable perfection of statement, but through a vision of absolute grandeur, a vision of a life-and-death combat."[1] The fundamental romanticism and heroism of Stieglitz's thought had in fact remained constant during his working life, although its expression evolved progressively toward a more intense and economical form. Evans, in contrast, had already set for himself the goal of an art that would seem reticent, understated, and impersonal.

Having rejected the two great models of the time, what example could Evans follow? In all fifty issues of Stieglitz's great periodical *Camera Work* he found only one picture that deeply moved him: Paul Strand's *Blind Woman* of 1915. But there was another kind of photography that was so plain and common, so free of personal handwriting, that it seemed almost the antithesis of art: the kind of photography that was seen in newspapers and newsreels, on picture postcards, and in the windows of real-estate dealers. Perhaps this blunt and simple vocabulary could be used with intelligence, precise intention, and coherence: with *style.* It is possible that Evans had read and remembered this advice from Flaubert: "An artist must be in his work like God in Creation, invisible and all-powerful; he should be everywhere felt, but nowhere seen. Furthermore, Art must rise above personal emotions and nervous susceptibilities. It is time to endow it with pitiless method, with the exactness of the physical sciences."[2]

Shortly after returning from Paris, Evans had become a favorite of Muriel Draper, writer and *saloniste* of intelligence, wit, and discrimination. Among those whom he came to know at her house was Lincoln Kirstein, still an undergraduate at Harvard and already a force in the re-focusing of American cultural life. In the decade that followed, Kirstein exerted a considerable influence on Evans' thought and career. Recalling his early relationship with Kirstein, Evans recently said: "Oddly enough, what happened was that this undergraduate was *teaching* me something about what I was doing—it was a typical Kirstein switcheroo, all permeated with tremendous spirit, flash, dash, and a kind of seeming high jinks that covered a really penetrating intelligence about and articulation of all aesthetic matters and their contemporary applications . . . The man was essentially explaining to me what I was doing in my work. It was immensely helpful and hilariously audacious."[3]

In the same years, Evans met Hart Crane and Ben Shahn; beginning about 1931 he and Shahn shared a Greenwich Village house for perhaps two years, and during one summer they worked together on Cape Cod. A little later in the Village he and James Agee also became friends—a relationship that perhaps proved as important to Agee's art as to Evans'. The major influences on Evans during his early photographic career were intellectuals, writers, and painters; it would seem that the one living photographer whom he awarded a grudging respect was Ralph Steiner, whose work of the twenties did anticipate in some respects the later work of Evans.

It is Evans' recollection that in these years he lived without money. If not quite literally true, the remembrance is perhaps not far from the fact. After returning from Paris he had taken a job as stock clerk in the brokerage house of Henry L. Doherty; he had even managed to get a job there for Hart Crane, who kept it less than a month before leaving in an alcoholic explosion. Evans himself was bitterly unhappy on Wall

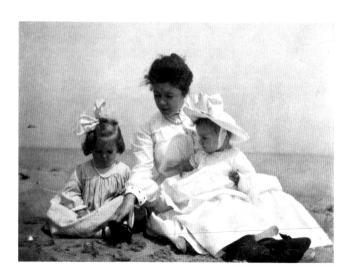 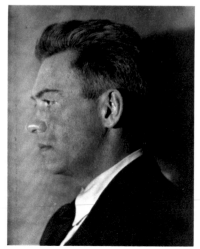 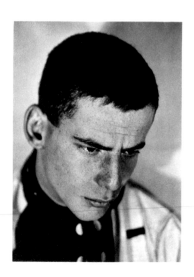

Street, and left it before the crash of 1929, with no prospects. In February 1931, Kirstein wrote in his diary: "Over to 14th St. and Fifth Ave. to call on Walker Evans, who lives with his German friend Hans Skolle in a particularly depressing penurious hole in the wall; how they both look so clean is a constant mystery to me. Their poverty is really so sad, always implied but never mentioned."[4]

The same month Kirstein suggested that Evans come with him and John Brooks Wheelwright to photograph the Victorian houses of the Boston area—Victorian architecture at that time being an unexplored mine of great interest to Kirstein. The project was executed during the spring of the year, and was evidently more complex than Kirstein, at least, had anticipated. To a bystander, the collaboration might even have had comic aspects. Kirstein noted that "the process technically was rather complicated even from the actual sighting, clicking, etc. of the camera itself. The sun had to be just right and more often than not we would have to go back to the same place two or even three times for the sun to be hard and bright. I felt like a surgeon's assistant to Walker, cleaning up neatly after him, and he a surgeon operating on the fluid body of time." And also, "Walker Evans . . . seems perpetually bored . . . I find it impossible to bully him by rushing him or telling him just what to do."[5] Evans on the other hand did feel both rushed and bullied; it seemed to him that Kirstein expected the building to surrender instantly on demand its deepest secrets to Evans' camera. When the project was finished it seemed to Kirstein far better than he had dared hope; for Evans, only a small handful of the pictures met his personal standards.

Those standards were both exacting and original. He thought of photography as a way of preserving segments out of time itself, without regard for the conventional structures of picture-building. Nothing was to be imposed on experience; the truth was to be discovered, not constructed. It was a formulation that freed

Walker Evans with older sister and mother, 1905 *Hart Crane, ca. 1930* *Lincoln Kirstein, ca. 1930*

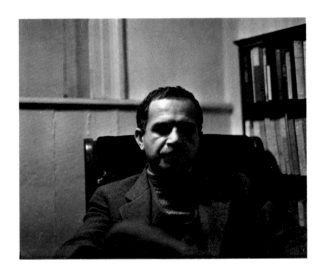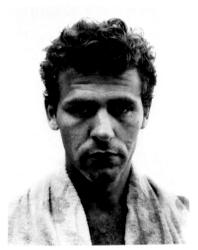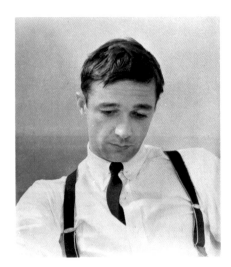

Evans' intuitions, and saved him from too solicitous a concern for the purely plastic values that were of central importance to modern painters. His first occasional successes had seemed to him almost gifts—the product not entirely of his own intention but of a force that had chosen him as a vehicle. From these pictures he had developed an increasingly conscious sense of the new kind of art that photography might become. By 1930 he was working with confidence and conviction. That year he told Kirstein that the possibilities of the medium excited him so much that he sometimes thought himself mad.

Evans' evolving style rested on two seemingly contradictory tenets. One was an uncompromising acceptance of precise and literal photographic description. The other was a faith in the validity of his intuitions. In defining his subject no theory or reasoned procedure could help; knowledge and sensibility must yield a single response. James Thrall Soby, who sought out Evans as a teacher in 1933, wrote later that he soon came to know in general terms what kind of subject matter would interest Evans. "But I never knew—and do not to this day—what made him decide what to encompass in the screen of his camera, from what distance, with what exploitation of the daylight and of the imponderables of plastic balance. These were problems he resolved with hypnotic certainty. The result was an imagery unmistakably his own."[6]

As Evans remembers his thought of the time, he wanted his work to be "literate, authoritative, transcendent." The photographer must define his subject with an educated awareness of what it is and what it means; he must describe it with such simplicity and sureness that the result seems an unchallengeable fact, not merely the record of a photographer's opinion; yet the picture itself should possess a taut athletic grace, an inherent structure, that gives it a life in metaphor.

It is possible to get the impression that the friends of the young Evans did not always understand him;

Ben Shahn, ca. 1934 *James Agee, 1937* *Walker Evans, ca. 1934*

or that they understood him but harbored a nagging suspicion that he did not understand *them;* or that they had not decided if they understood him, but were not quite willing to forego his company, although it was sometimes aggravating, half-enchanting, and subtly, intangibly patronizing, in the manner mastered only by the educated poor. One friend noted that Evans' undeniable magnetism was continually at half voltage—flickering, lethargic, perhaps teasing; possibly, the friend thought, he was actually undernourished. Or perhaps he was immobilized by the role of spectator—the photographer's role. Perhaps the best photographers in their best years come to resemble their unexposed film—passive, unprejudiced, patient, waiting for the revelation that will open the shutter. Muriel Draper spoke to Kirstein of the subtle and powerful influence that Evans exerted on their group, of the mysterious quality that he projected, knowingly or otherwise.

Evans lived precariously and worked prodigiously. Infrequent small assignments, and the interest of friends, made it possible to work, and occasionally to travel. Ernestine Evans (no relation) secured for him the job of making photographs for Carleton Beals's book *The Crime of Cuba,* which Evans did not find time to read. Kirstein commissioned him to photograph the School of American Ballet. In 1934 he photographed for The Museum of Modern Art the contents of its exhibition "African Negro Art." In 1935 he went to the American South to photograph ante-bellum architecture for a book that never materialized. More often than not, what seemed small opportunities were made the occasion for important works.

Although the photographs reproduced in the present book span a period of some forty years, forty-two of the one hundred pictures were made during an eighteen-month period beginning late in 1935. Almost half of the plates in Evans' *American Photographs* and all of those in *Let Us Now Praise Famous Men* were made during the same year and a half, and this total by no means exhausts the work of first quality done during this astonishing creative hot streak. The period in question represents the first time in Evans' life as a photographer (and for some years following, the last time) during which he was able to concentrate on his work with the assurance of a regular income.

These were the months of Evans' service with the photographic unit of the Resettlement Administration, later called the Farm Security Administration. This small group of photographers achieved what was probably the outstanding success of all the creative make-work projects of the Depression period.

To the degree that the FSA photographic group (euphemistically called the Historical Unit) had a coherently conceived function, it was to make pictures that would explain and dramatize the plight of the rural poor to the urban poor—and thus help preserve the tenuous coalition which had brought the New Deal to power. Its theoretical purpose was thus by implication political, but to the photographers in the field it was

an opportunity to make true photographs, away from the carping help of editors or clients, and even away from the advice of bureaucrats.

The project was administered by Roy Stryker, former economics student of Rexford G. Tugwell at Columbia University, who was summoned in 1935 to rejoin the older man in Washington. Neither Stryker nor Evans was the easiest of men, and their relationship was frequently a difficult one. Evans felt that it was his work, and his ideas (with those of Ben Shahn and Ernestine Evans), that had been appropriated to form the style and the sense of purpose of the unit, and there was considerable truth, as well as a touch of paranoia, in this position. Stryker admitted years later that Evans' work and thought, in the early days of the project, had greatly expanded his sense of what photography could be; nevertheless he could not quite bring himself to be comfortable with the man. Evans was not, in Stryker's terms, a warm person. In addition, Stryker thought of the project as a group effort, while Evans knew that artists do their important work alone. Stryker thought (much of the time) that the unit's function was to help reform the ills of the country, and Evans thought that an artist's function was to describe life. Stryker thought that the meaning of the pictures was clear, and Evans found the best of them inexhaustibly mysterious. Even worse, Stryker was an extroverted, outspoken, hard-driving optimist, a latter-day populist, while Evans was an introverted, ironic, skeptical aristocrat. When the unit faced a budget reduction in 1937 it is not surprising that Evans was the one to be cut loose.

In the following year a major exhibition of Evans' work was shown at The Museum of Modern Art, accompanied by the monograph *American Photographs.* The exhibition and book were widely and seriously —and for the most part sympathetically—reviewed. Most critics, sympathetic or otherwise, characterized the content of the work with words like *wretchedness, disintegration, waste, chaos, decay.* John William Rogers said that the pictures "testify the symptoms of waste and selfishness that caused the ruin in our civilization."[7]

It was, and is, supposed that Evans' work was basically concerned with the causes of social reform— presumably because his pictures often dealt with humble people and their works. But if his subjects were humble, they were almost never ordinary; it was above all quality that he demanded of them. His idea of quality was not a sentimental one, and could not be reduced to hortatory slogans. The subject got no credit for being either grand or modest, esoteric or vulgar, old or new. It got credit only for being good: meaning full of the record of life, or failure, or promise, or style. Evans was concerned with purifying not institutions but experience.

The most perceptive of his critics understood this. Thomas Dabney Mabry wrote that the work possessed "a power which reveals a potential order and morality at the very moment that it pictures the ordinary, the

vulgar, and the casually corrupt."[8] In what seems today the most astonishingly just explanation of the work, William Carlos Williams said: "It is ourselves we see, ourselves lifted from a parochial setting. We see what we have not heretofore realized, ourselves made worthy in our anonymity."[9]

Lincoln Kirstein's essay in *American Photographs* appraised the work in terms which perhaps seemed extravagant then, but which today seem both bold and measured: "Compare this vision of a continent as it is, not as it might be or as it was, with any other coherent vision that we have had since the war. What poet has said as much? What painter has shown as much? Only newspapers, the writers of popular music, the technicians of advertising and radio have in their blind energy accidentally, fortuitously, evoked for future historians such a powerful monument to our moment. And Evans' work has, in addition, intention, logic, continuity, climax, sense and perfection."

Evans abhorred artiness, for it was the substitution of aspect for fact; but the subject matter of his own work was very often a kind of incipient art: the promising beginnings and honorable failures and fragmented shards of an American sensibility, which if respected might someday rise up to become a coherent and persuasive style of life and value. As Le Corbusier had attempted to reject the models of the grand tradition, and had gone to the grain elevator and the airplane and the hardware catalogue for the beginnings of a new architectural vocabulary, so Evans rejected the accepted successes of picture making, and began again instinctively with the nourishment that he could find in hand-painted signs, amateur buildings, the humbler varieties of commercial art, automobiles, and the people's sense of posture, costume, and design.

It has been suggested that Walker Evans (or Eugène Atget, or photography in general) was the father of those tendencies which flourished in painting around 1960 under the label of Pop Art. It would in fact be difficult to imagine either the aspect or the substance of this art coming into existence without its photographic precedents. However if one compares the pictures of Evans to later Pop paintings of similar iconography and design, the differences seem more important than the similarities. The descriptive and elusive complexity, the richer ambiguity, the reticence of Evans' pictures result not in parody but in mystery.

Although Evans was in Paris at the time when Eugène Atget's work received its first limited public attention, he was not then interested in photography, and he did not see Atget's work until about 1930 in New York, when it came as a confirmation of his own intuitions. It was probably about the same time that he first looked with attention at the work of the photographers of the American Civil War. Lincoln Kirstein, whose given name reflected his own family's remembrance of that war, had preserved his grandfather's collection of photographs of the conflict.

William Ivins, Jr. claimed that the only sensible way to read history was to read it backwards. In the

present case it is perhaps true that our appreciation of Atget and the Brady group owes as much to our knowledge of Evans' work as that work owes to their earlier example. Without doubt, Evans' pictures have enlarged our sense of the usable visual tradition, and have affected the way that we now see not only other photographs, but billboards, junkyards, postcards, gas stations, colloquial architecture, Main Streets, and the walls of rooms. Nevertheless Evans' work is rooted in the photography of the earlier past, and constitutes a reaffirmation of what had been photography's central sense of purpose and aesthetic: the precise and lucid description of significant fact. That Evans did not in the beginning know the work of Atget, or of the half dozen men who were then called by the generic name of Mathew Brady, is not important; there were hundreds of others who used photography in a similar spirit. (Atget himself differs from many other excellent photographers of his time because of the quality of his eye and mind, not because of the novelty of his conception.) The basic vocabulary and function of undiluted photography were universally visible for all to see; its exceptional use demanded only an exceptional artist.

The tracing of influences in photography is at best a perilous business. The modern photographer, like everyone else, is bombarded by a continuous flood of camera images—an assault on his eyes so massive and chaotic that he often does not himself know which pictures have left a residue of challenge in his mind. The influence of an exceptional photographer works less through his pictures' first impact than through their staying power: their ability to implant themselves like seeds in a crevice of the mind, where the slow clockwork of germination begins.

To most photographers in the late thirties, the work of Walker Evans probably seemed not radical, but idiosyncratic. In some ways his pictures seemed willfully old-fashioned. At a time when faster lenses and films and shutters allowed photographers to record ever-thinner slices of life, Evans' pictures were as still as sculpture. While the new miniature cameras were spawning an unending stream of bird's-eye and worm's-eye views, Evans worked insistently from a human's-eye level. While artificial lighting equipment grew continually more sophisticated and seductively ingenious, Evans preferred the light that the sun, or chance, provided. While the new picture magazines rewarded photographers who recorded the exotic, the charming, the topical, the glamorous, and the shocking, Evans interpreted what was ubiquitous and typical.

In time the slick professional performances and the tortuous amateur novelties that had filled the pages of the period's photography annuals faded mercifully from memory. Twenty years later, the photography of the thirties was remembered for a small handful of artists whose work and thought had remained in the mind. Of these few, none has had an influence deeper than Evans, nor one broader in reach: the work of such disparate younger photographers as Robert Frank and Harry Callahan (and in turn, the work of their

own photographic descendants) is marked by Evans' earlier achievement. His influence, moreover, has been of a variety that has produced no, or few, acolytes; his work has seemed most useful to those with independent minds.

Evans worked at a slower pace in the years after *American Photographs*. In 1943 he joined the staff of *Time* magazine as a writer, and two years later he transferred to *Fortune* as writer and photographer. Predictably, the environment of group journalism was not a wholly sympathetic one to an artist as stubbornly self-directed as Evans. He recently remarked that "in those days there was a certain satanic naïveté in the very top editorial direction of Time Incorporated, perceptible only from below: intelligent, gifted employees were expected to work hard and long hours under crushing pressure at many tasks no man with a mind could put his heart into." Evans did maintain a remarkable degree of independence at *Fortune,* but it was perhaps an independence purchased at the price of that continual vigilance which in itself frustrates free expression. Between 1945 and 1965, when he retired from the magazine, Evans produced some forty portfolios and photographic essays, often self-assigned and with his own accompanying text. The pictures made for *Fortune* exhibit the clarity and intelligence that are the essence of the Evans style. It must also be said that they often lack the sense of fierce conviction that identifies his best work. Evans at his best convinces us that we are seeing the dry bones of fact, presented without comment, almost without thought. His lesser pictures make it clear that the best ones had deceived us: what we had accepted as simple facts were precise descriptions of very personal perceptions.

If Evans' best later work has been produced at a slower and more irregular pace, it has nevertheless been profoundly rewarding when it has appeared. In 1938 and 1941 Evans made his secret series of anonymous subway riders. This collection constitutes a kind of virtuoso piece, in which the photographer knowingly sacrificed all of his basic controls except one. To make these pictures by the feeble light of the subway cars, Evans sat in what he later called the swaying sweatbox for hundreds of hours, riding to nowhere, with the lens of a Contax camera peering from between two buttons of his topcoat, and his eyes focused on the bench opposite. He had to forego the freedom to choose his angle of view, the control of precise framing, the selection of light, the free choice or direction of his subjects. All that remained was the freedom to say yes or no—to squeeze the cable release hidden in his sleeve, or not. The almost absolute lack of "purely visual" interest in this series provides an appropriate setting for the astonishing individuality of Evans' subjects and fellow riders—an individuality not so much of their roles and stations as of their secrets.

The Chicago street portraits of the mid forties, also made from a fixed vantage point, were a continuation of Evans' experiment with subjects over which the photographer's control had been reduced to a minimum.

Here however the subject was more complex, and in motion; the photographer's yes-or-no decision became progressively more intuitive, and its results less predictable. A selection of these pictures was exhibited at The Museum of Modern Art in 1948, and several were published the next year in *U.S. Camera Annual 1949*. It would seem that they were among the most stimulating pictures of the period to the next-younger generation of American photographers.

Perhaps the ultimate projection of these experiments was the group of pictures made in 1950 and earlier of the American industrial landscape as seen from the windows of moving trains. This linked sequence of investigations—the subway pictures, the Chicago street portraits, and the snapshots from trains—constituted a direct challenge to the conventional notions of serious photography of the time, by embracing rather than disputing the element of chance.

In the late forties James Agee, who had learned much about photography from his friend Evans, wrote that "luck . . . is one of the cardinal creative forces in the universe, one which a photographer has unique equipment for collaborating with."[10] *Collaborating* is probably the correct word, better than *competing,* even though the serious photographer will not accept luck blindly, but will do his best to outwit it, and trick it into serving his own prejudices. He knows in any event that luck, even when it defeats him, is the source of the ideas that he will hopefully resolve tomorrow. Luck to the photographer represents the appearance of unsolved problems; it means to him much what Nature meant to the nineteenth-century painter.

In his serious pictures of the past twenty years, Evans has abandoned this duel with chance, and returned to the poised and contemplative style of his youth. He has however directed the intelligence and wit of that vision inward, toward a content that is often almost autobiographical. If there is a hint of mockery in these later pictures it is perhaps the self-mockery of a middle-aging pilgrim, who has discovered that his own principality is as rich in miracles and heresies as those of strangers. How surprising to find that documentary photographs (cool, precise as a police report, emotionally aloof) can be made in the apartments and weekend houses of one's friends, or in a child's bedroom in Stockbridge, Massachusetts. The secrets of the lives of Alabama sharecroppers and dead Victorians were recorded—so we supposed—for our edification. For whose eyes then are our own secrets revealed?

In addition to continuing his career as an artist, Evans today (because of his importance as exemplar to young photographers) has had imposed upon him the role of prophet. This is a situation that Evans might regard with both embarrassment and amusement. Since paradox and irony have been constant elements in his own work, it is perhaps poetic justice that Evans should now find himself in a position similar in some respects to that of Stieglitz in 1929, when demanding young geniuses called on *him*. As Professor at Yale

since 1965, Evans has approached the function of teaching (the function of achieving a beneficent relationship with the young) with a characteristic respect for the privacy of other minds. His teaching combines a tutorial informality of method with a tactful reserve in attitude, reflecting Evans' distaste for the tendentious.

IT IS DIFFICULT to know now with certainty whether Evans recorded the America of his youth, or invented it. Beyond doubt, the accepted myth of our recent past is in some measure the creation of this photographer, whose work has persuaded us of the validity of a new set of clues and symbols bearing on the question of who we are. Whether that work and its judgment was fact or artifice, or half of each, it is now part of our history.

Individually, the photographs of Walker Evans evoke an incontrovertible sense of specific places. Collectively, they evoke the sense of America. Writing in 1938 of an Evans photograph, Thomas Mabry said this: "Look across the river, down into Easton, Pennsylvania. I think it is a spring day. The whole town lies there. I was not born in Pennsylvania, nor in a city, and yet I think I must have been born here."[11]

NOTES

1 Harold Clurman. "Alfred Stieglitz and the Group Idea." In Waldo Frank *et al.,* eds., *America and Alfred Stieglitz: A Collective Portrait.* Garden City, N. Y.: Doubleday, Doran & Company, Inc., 1934, p. 272.

2 Francis Steegmuller, ed. *The Selected Letters of Gustave Flaubert.* New York: Farrar, Straus & Young, Inc., 1953, p. 195.

3 Interview with Leslie Katz, to be published in *Art in America* (New York), March 1971.

4 Lincoln Kirstein. Unpublished diaries, February 1931.

5 *Ibid.,* April 1931.

6 James Thrall Soby. "The Muse Was Not for Hire." *Saturday Review* (New York). Vol. 45, Sept. 22, 1962, p. 58.

7 John William Rogers. "Odd Photographs on Exhibition in New York Museum." *Times-Herald* (Dallas, Tex.). October 30, 1938.

8 Thomas Dabney Mabry. "Walker Evans's Photographs of America." *Harper's Bazaar* (New York). November 1, 1938, p. 85.

9 William Carlos Williams. "Sermon with a Camera." *New Republic* (New York). Vol. 96, October 12, 1938, p. 282.

10 James Agee. "A Way of Seeing." In Helen Levitt and James Agee, *A Way of Seeing.* New York: Viking Press, 1965, p. 8.

11 Mabry, *op. cit.* p. 104.

Plates

BROOKLYN BRIDGE, NEW YORK, 1929

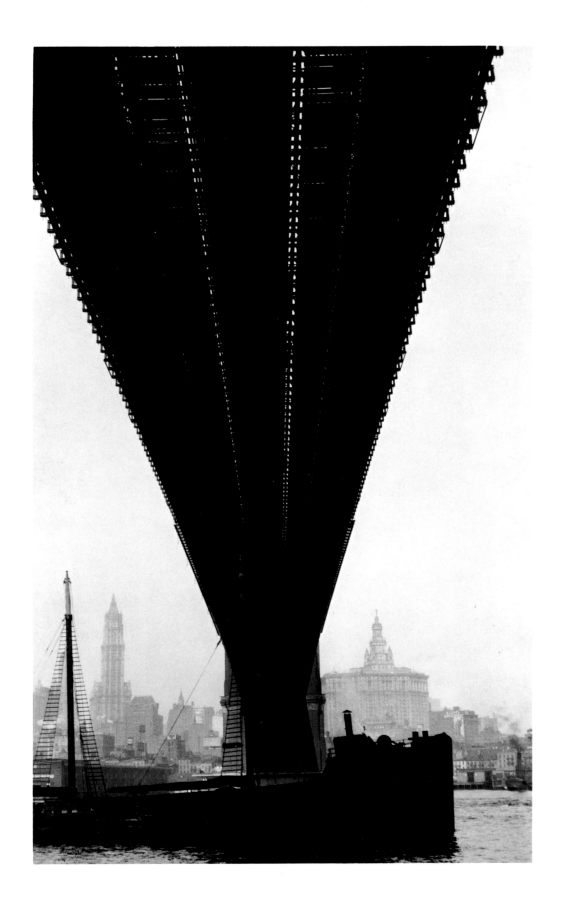

STORE WINDOW, BROOKLYN, CA. 1931

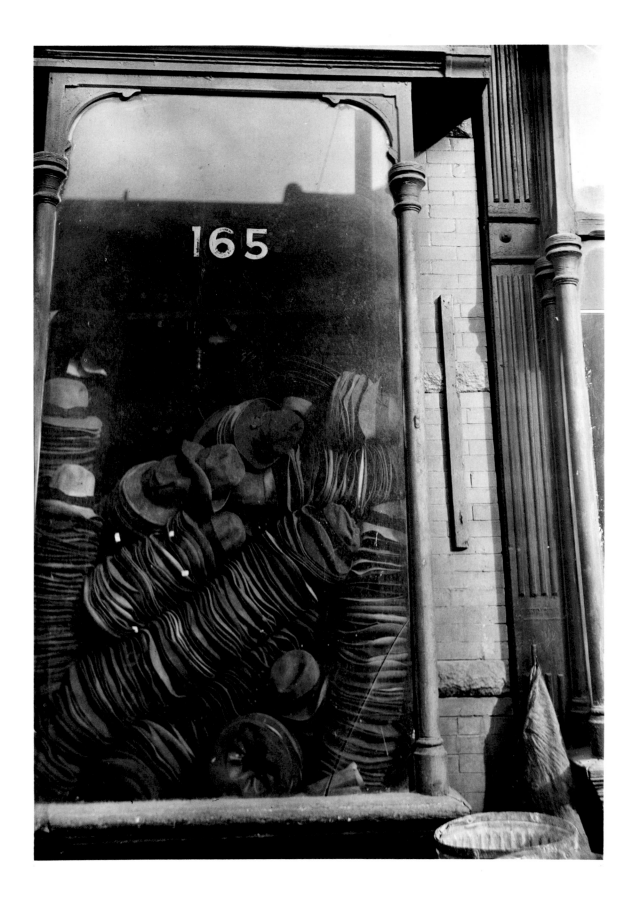

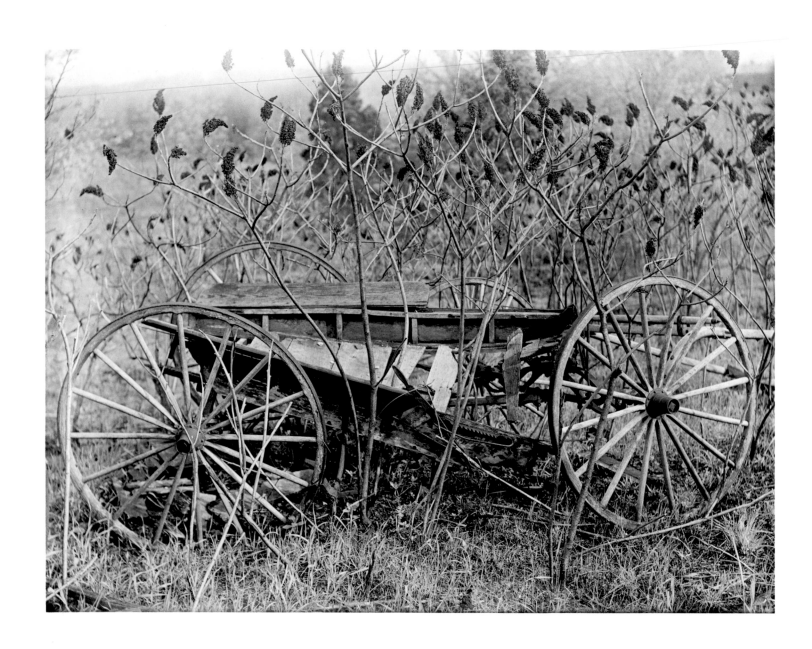

SOMERSTOWN ROAD, OSSINING, NEW YORK, 1931

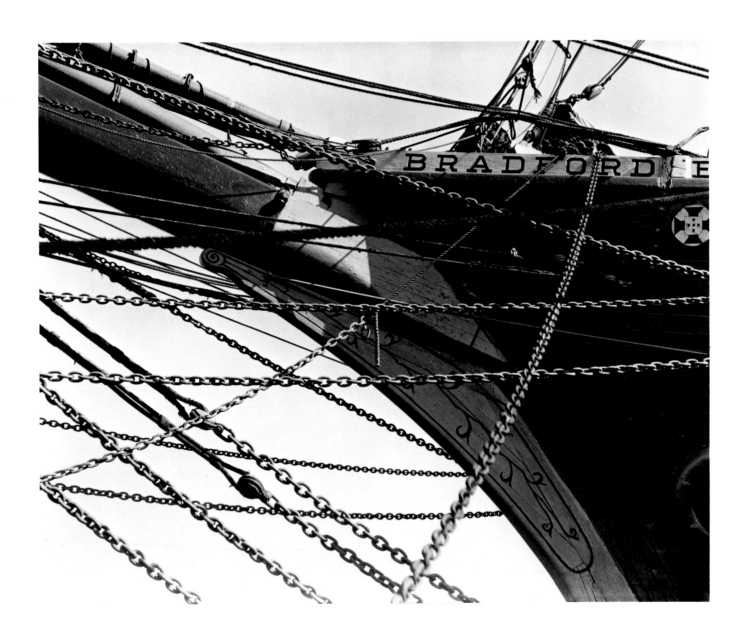

NEW BEDFORD, MASSACHUSETTS, 1931

222 COLUMBIA HEIGHTS, BROOKLYN, N.D.

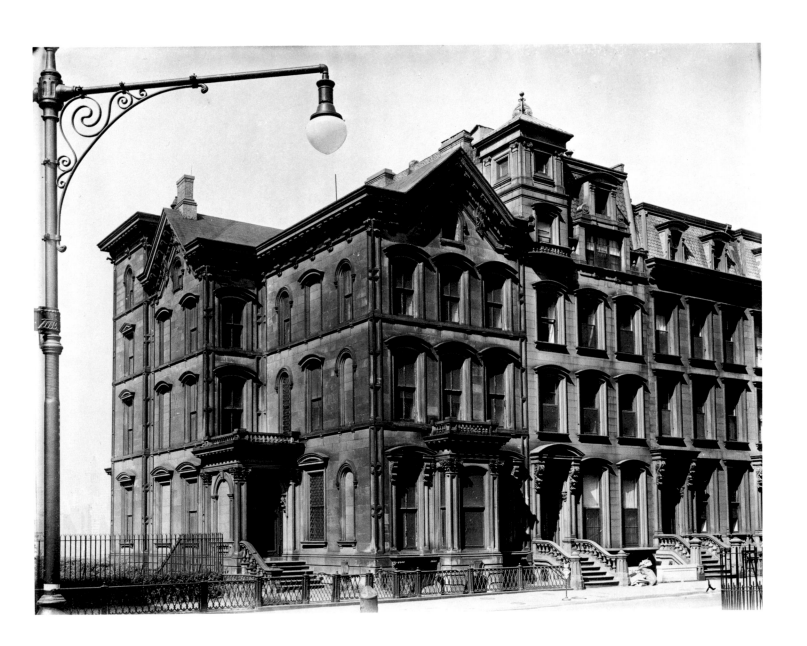

29

DOORWAY, 204 WEST 13TH STREET, NEW YORK, CA. 1931

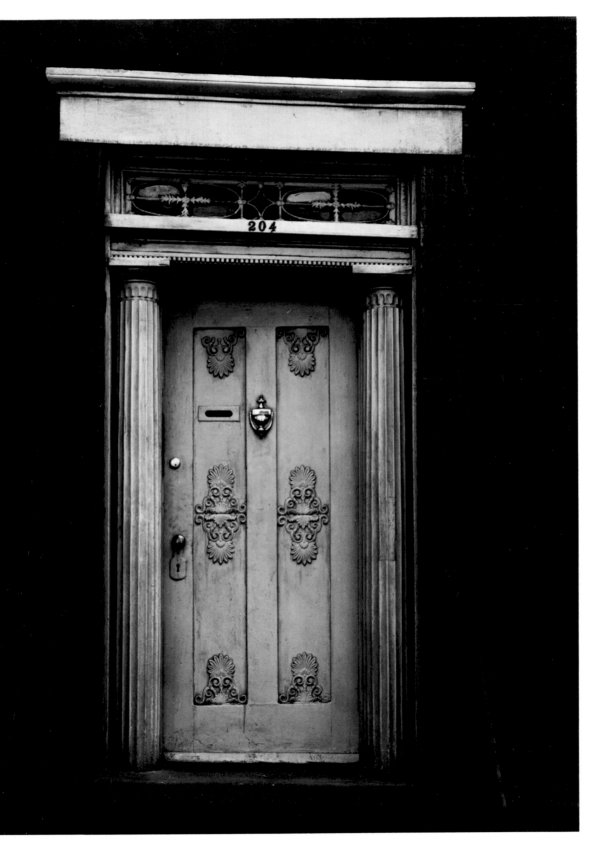

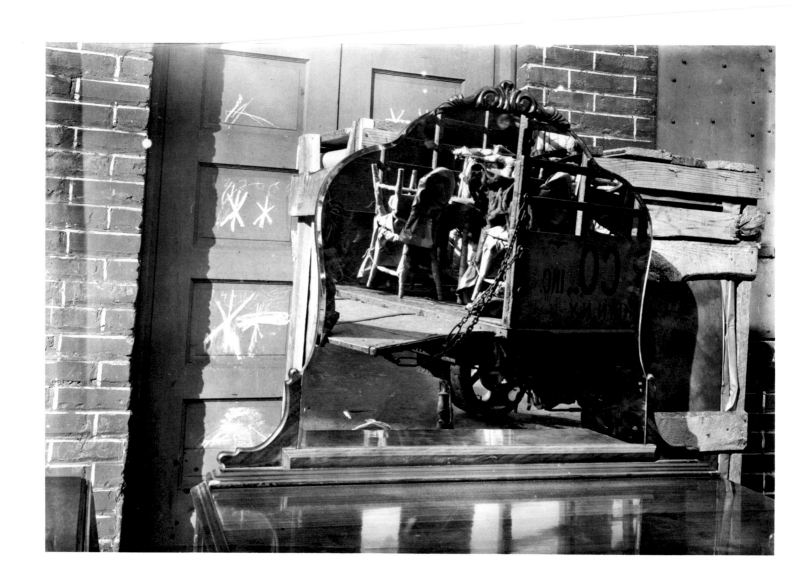

STREET SCENE, BROOKLYN, CA. 1931

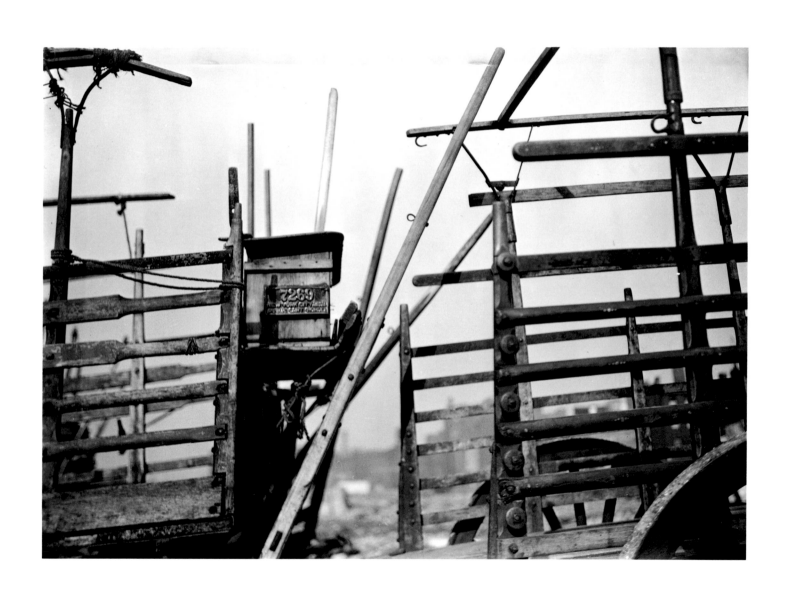

OLD WALLABOUT MARKET, BROOKLYN, 1930

KITCHEN, TRURO, MASSACHUSETTS, 1931

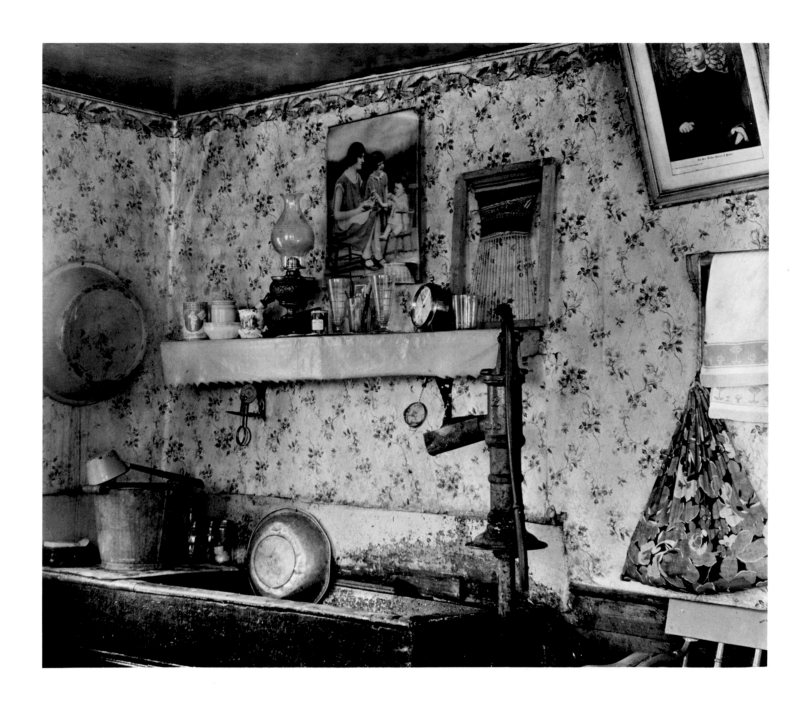

35

CARY ROSS'S BEDROOM, NEW YORK, 1932

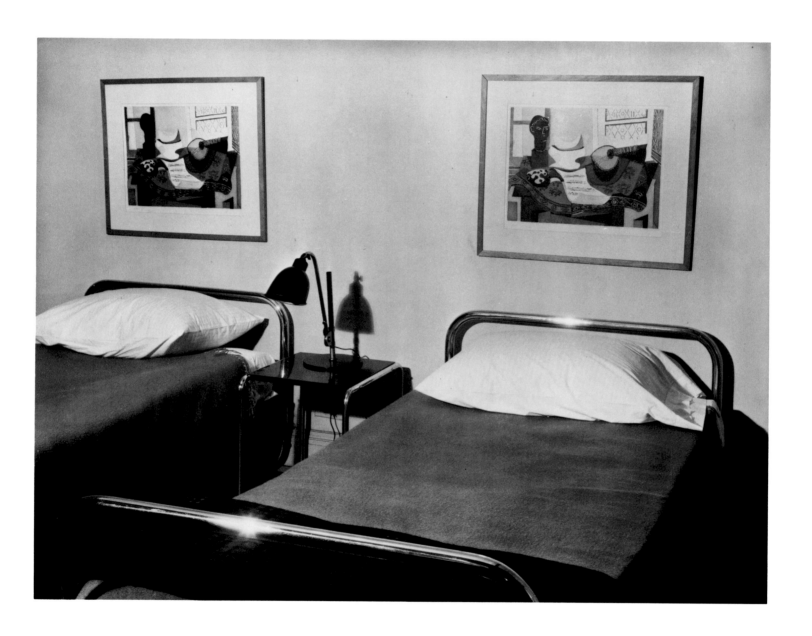

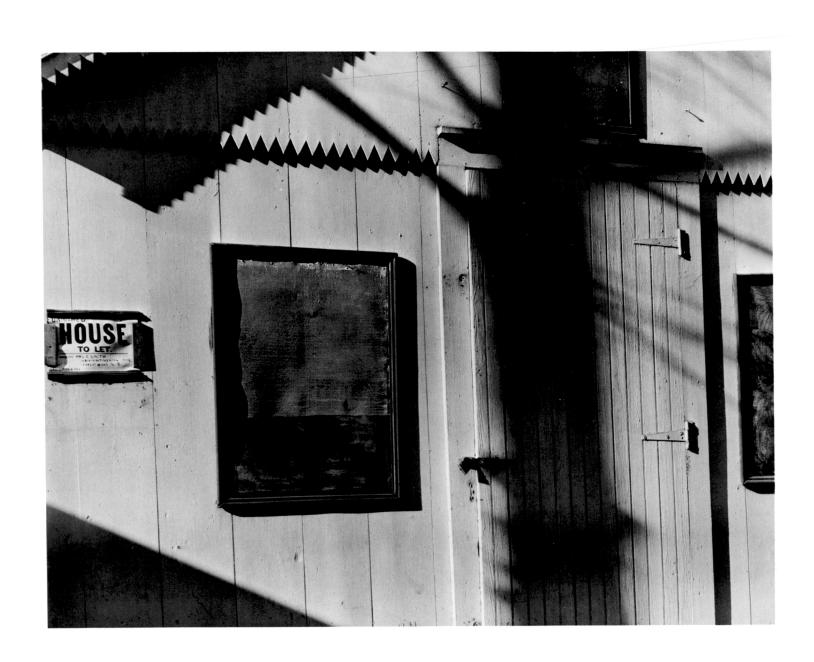

Cottage at Ossining Camp Woods, New York, 1930

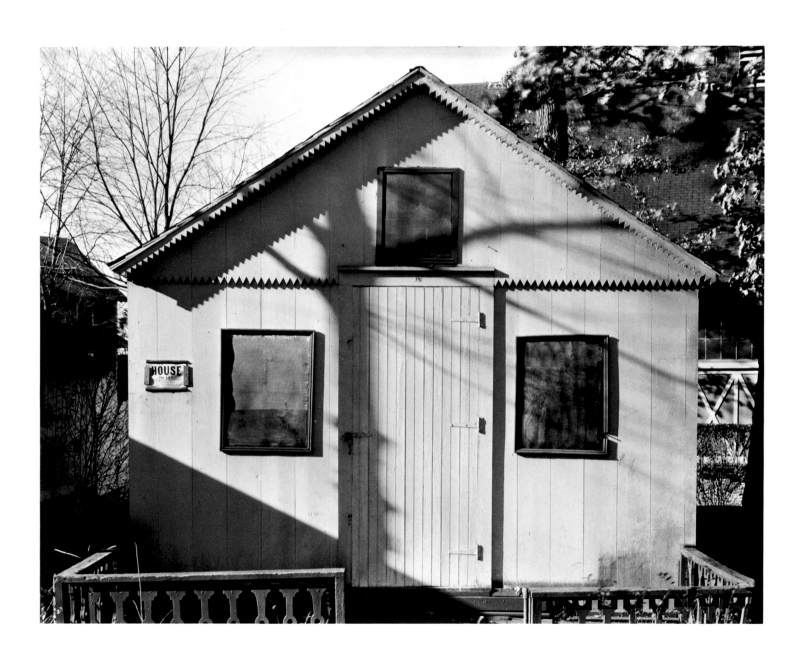

COTTAGE AT OSSINING CAMP WOODS, NEW YORK, 1930 39

Ossining, New York, 1931

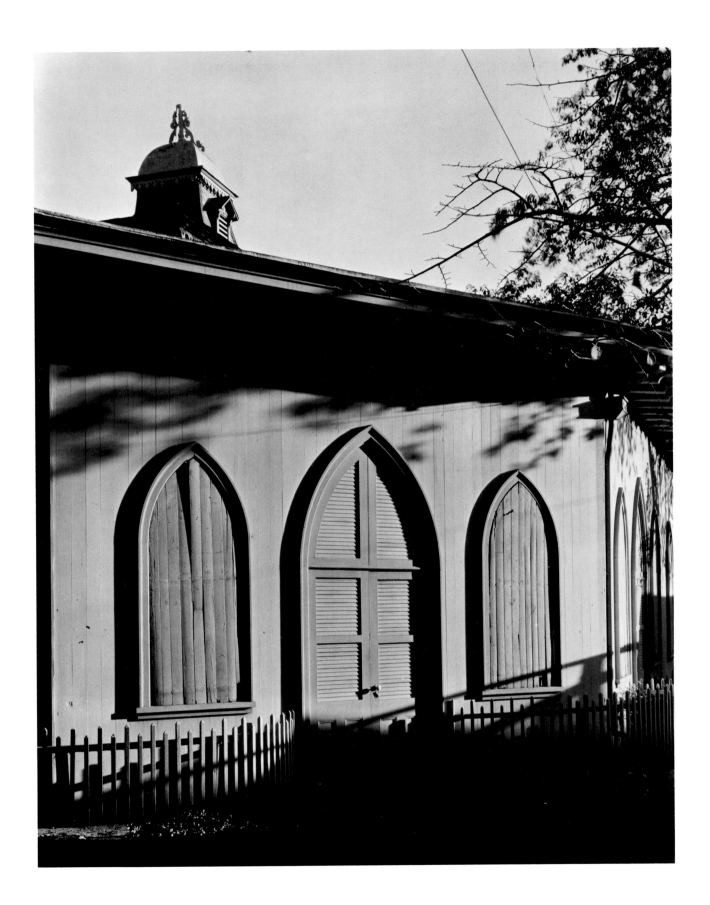

Doorway, Nyack, New York, ca. 1931

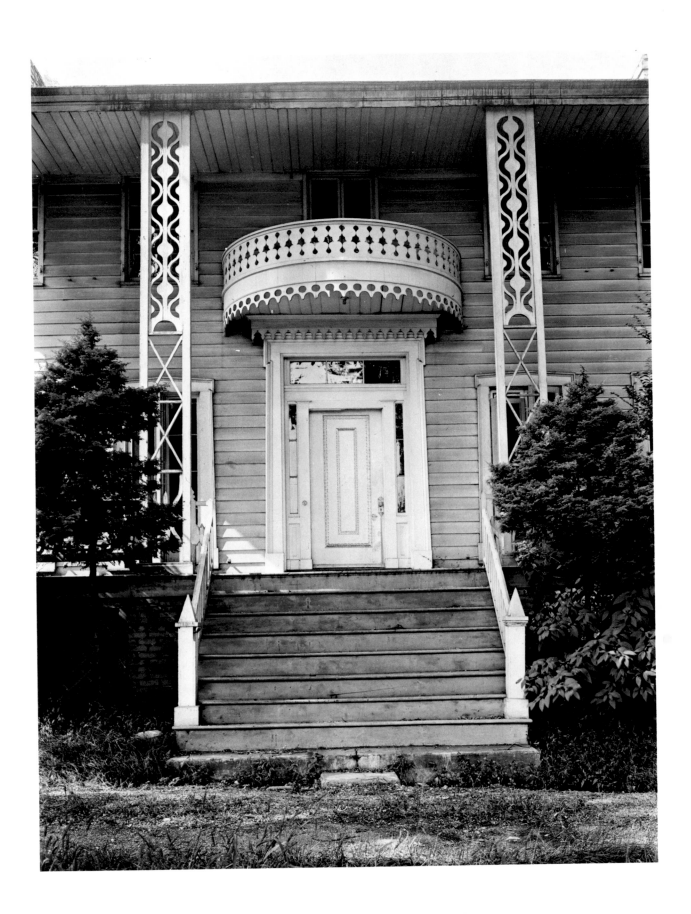

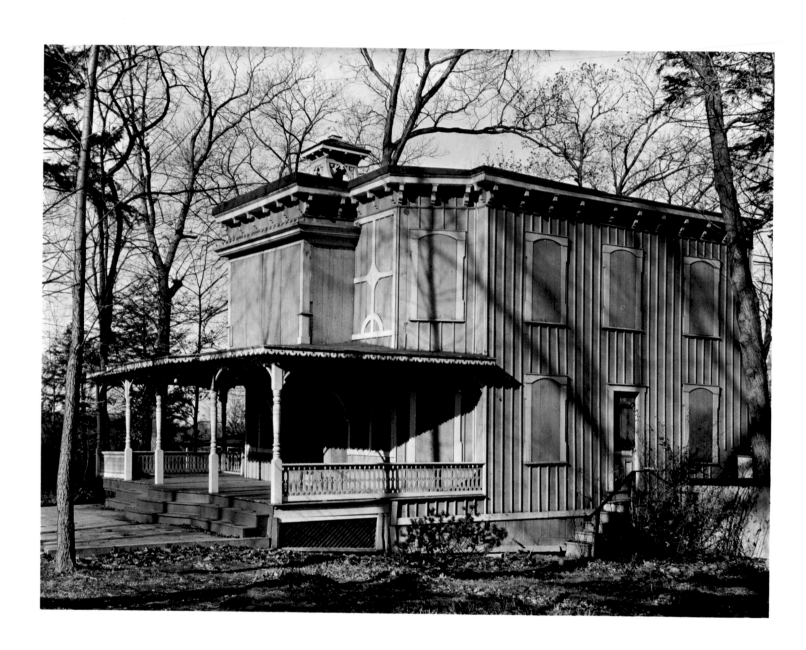

OSSINING, NEW YORK, 1931

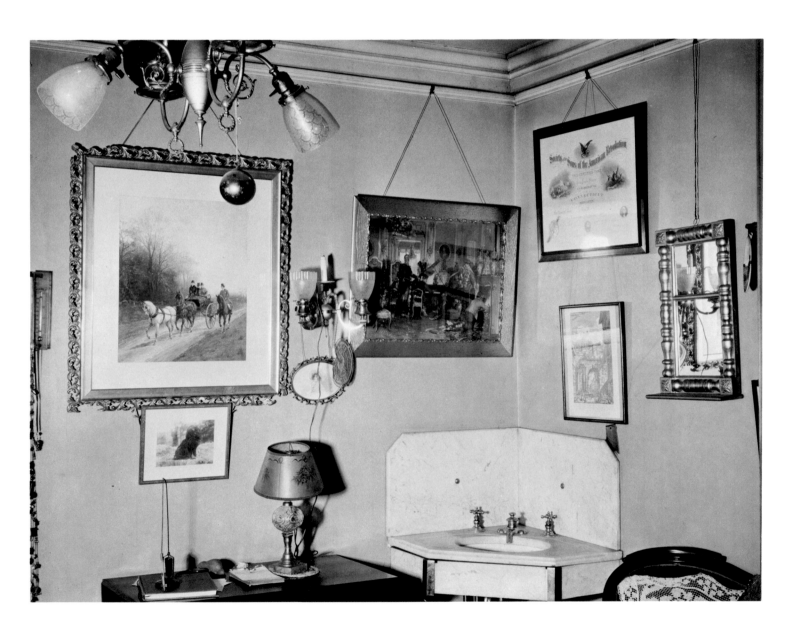

INTERIOR, STORRS HOUSE, HARTFORD, CONNECTICUT, CA. 1933

45

Junked Auto, Cape Cod, ca. 1930

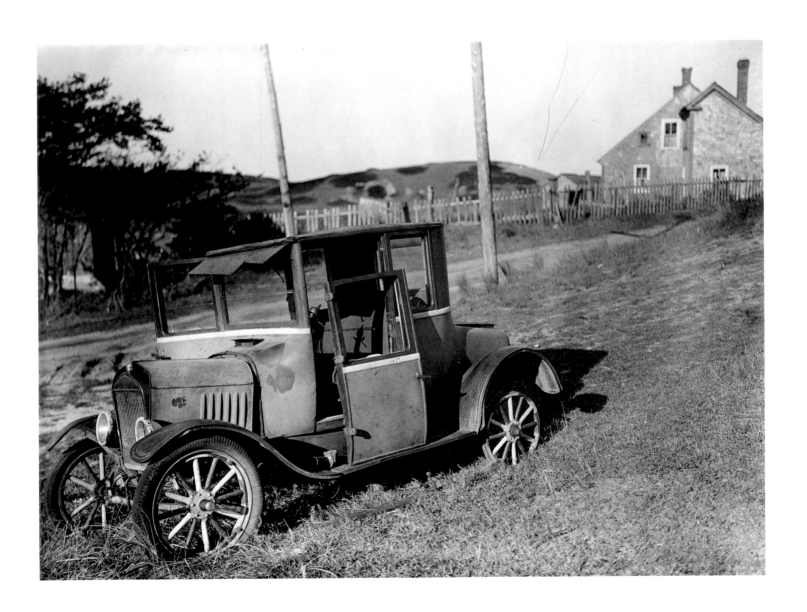

47

BOWERY LUNCHROOM, NEW YORK, CA. 1933

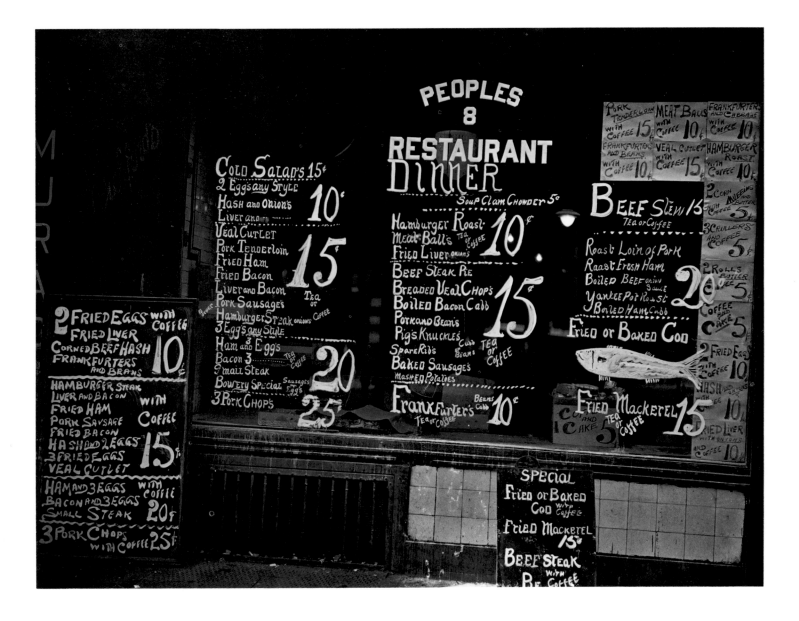

49

Woman and Children, Havana, 1932

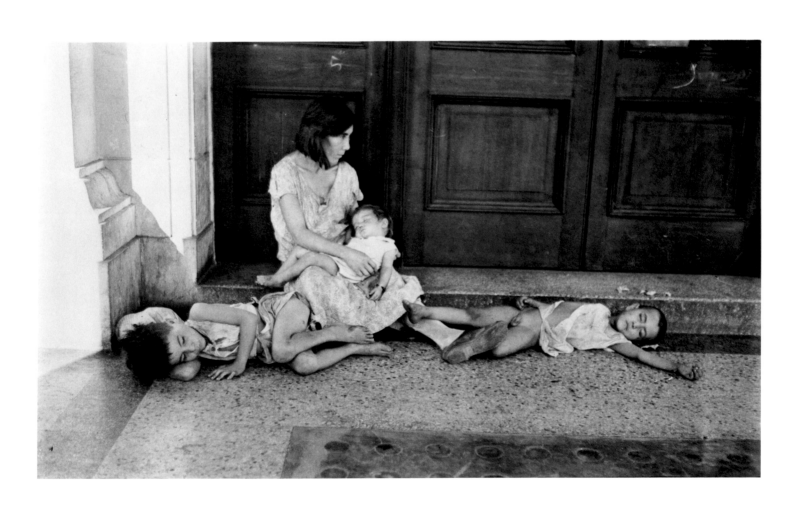

Dock Worker, Havana, 1932

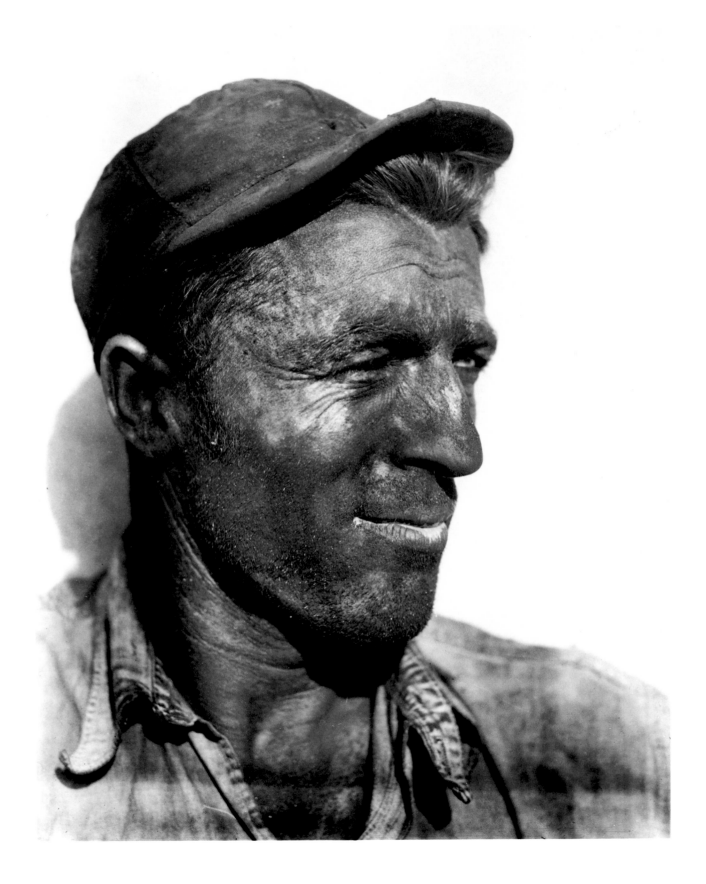

DOCK WORKERS, HAVANA, 1932

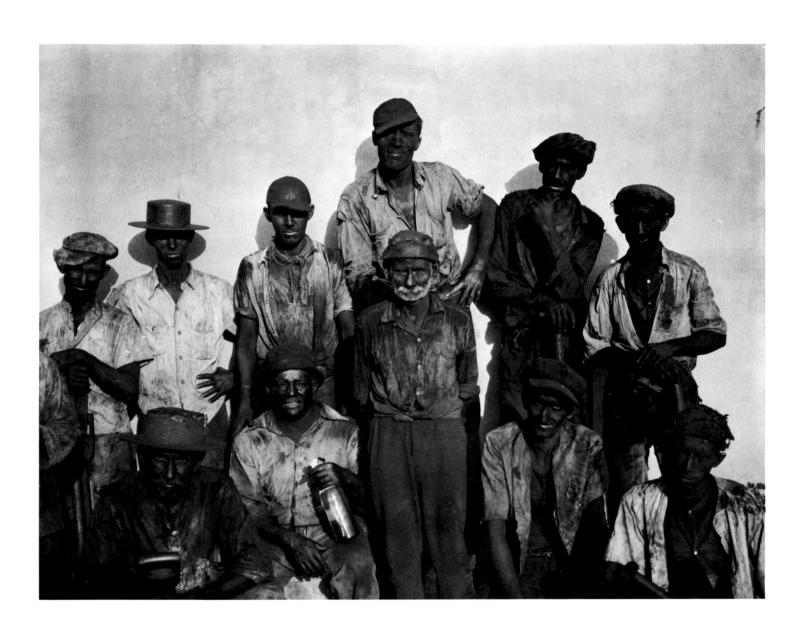

DOCK WORKERS, HAVANA, 1932

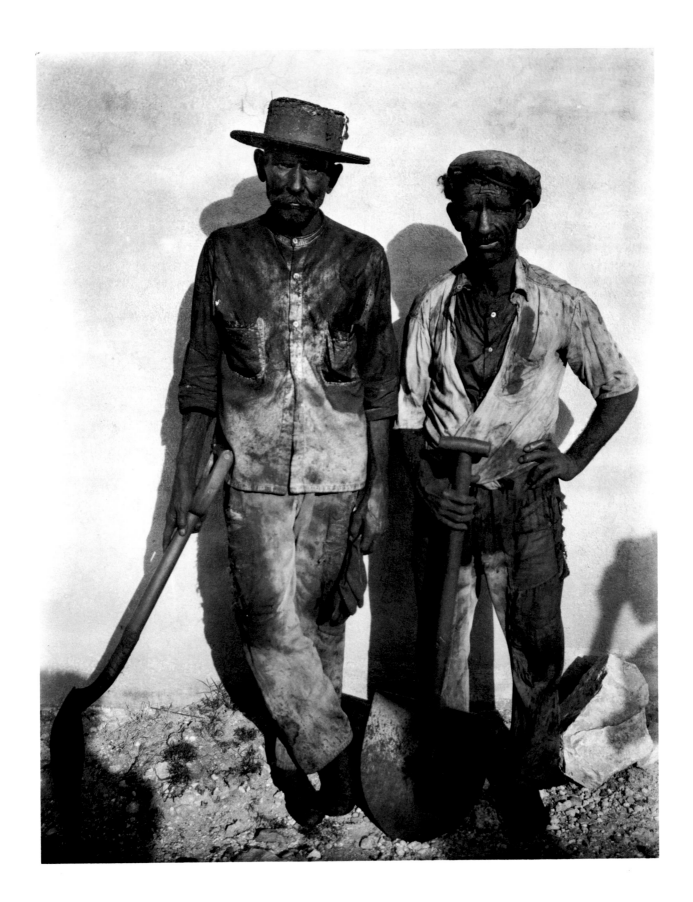

Courtyard, Havana, 1932

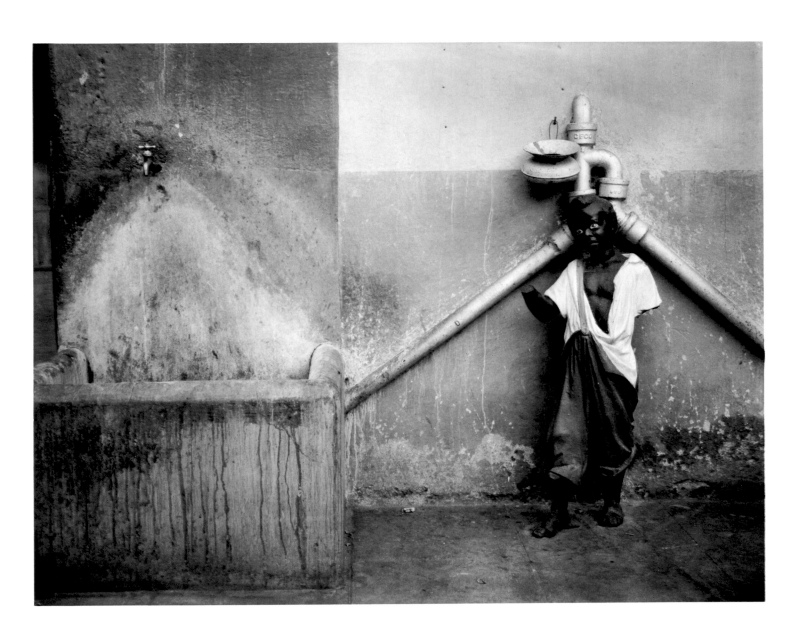

BELLE GROVE PLANTATION, WHITE CHAPEL, LOUISIANA, MARCH 1935

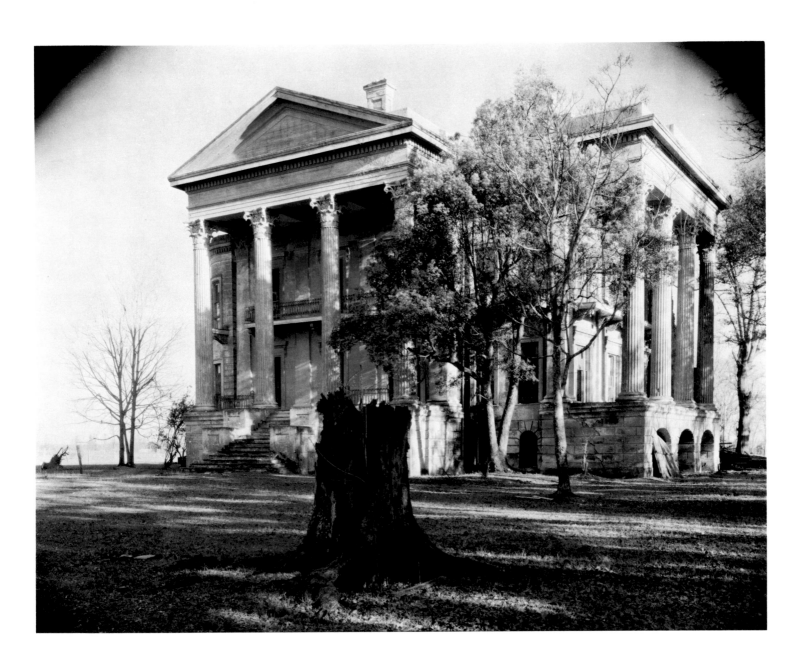

61

WATERFRONT POOLROOM, NEW YORK, 1933

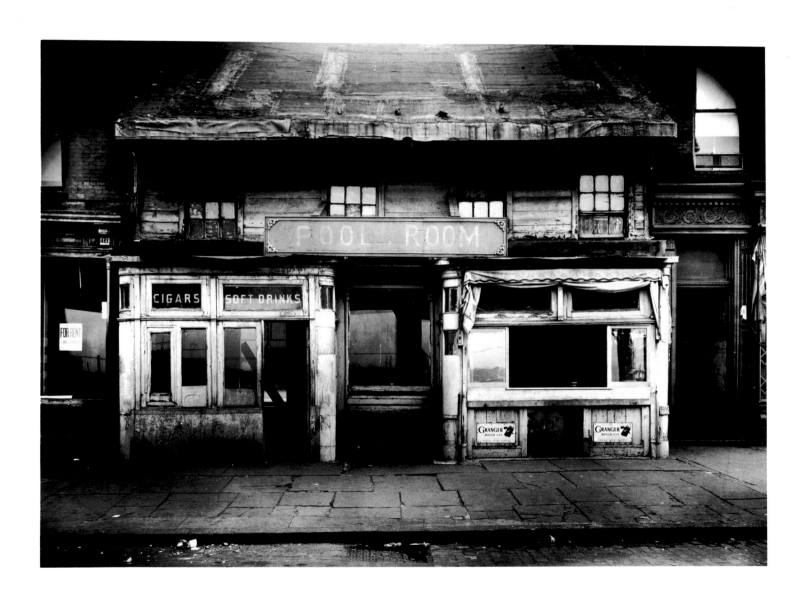

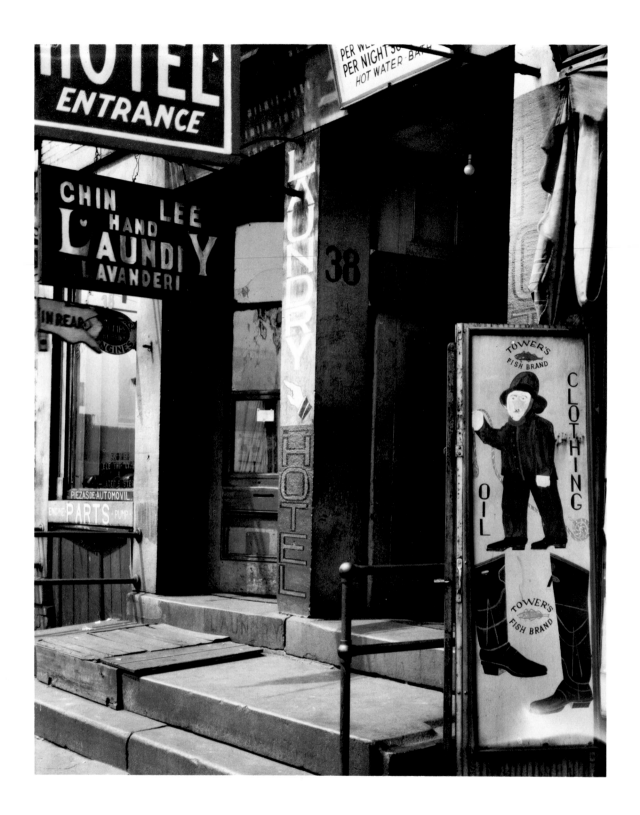

BOWERY FLOPHOUSE ENTRANCE, NEW YORK, 1934

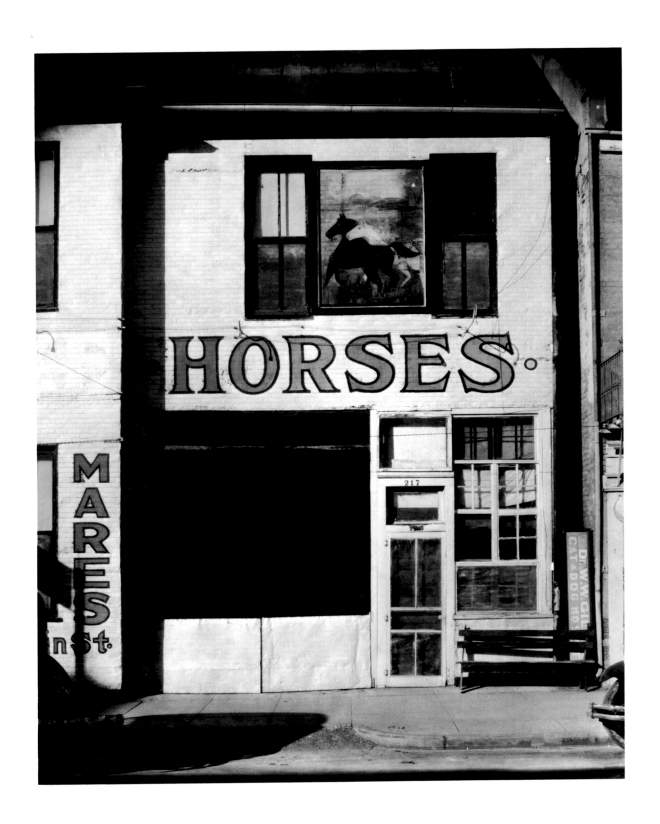

STABLES, NATCHEZ, MISSISSIPPI, MARCH 1935

Fulton Market Area, New York, ca. 1934

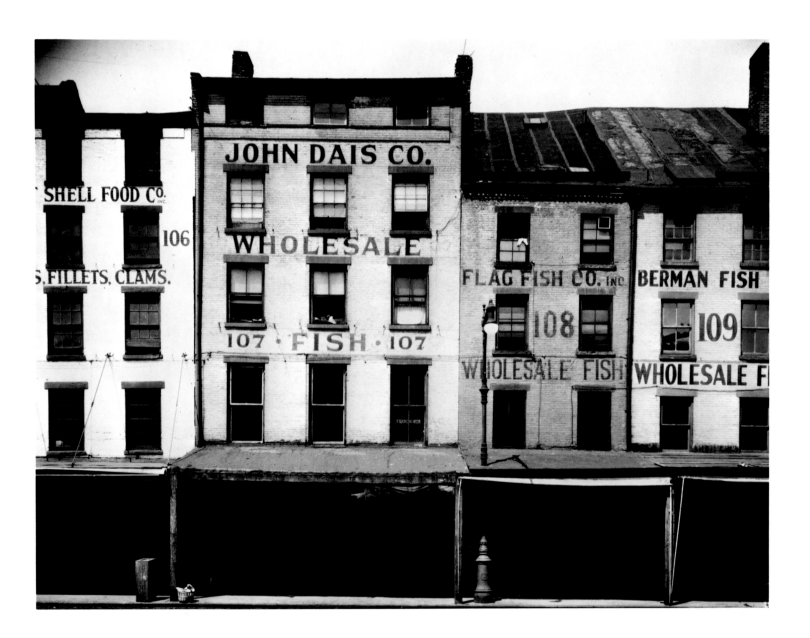

Uncle Sam Plantation, Convent, Louisiana, March 1935

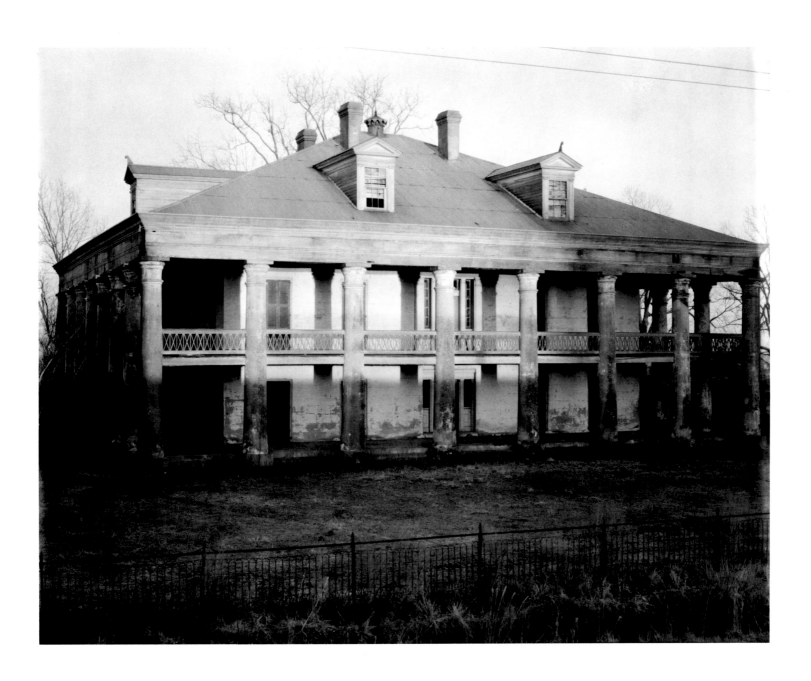

CRANE HOUSE, SOMERS, NEW YORK, CA. 1934

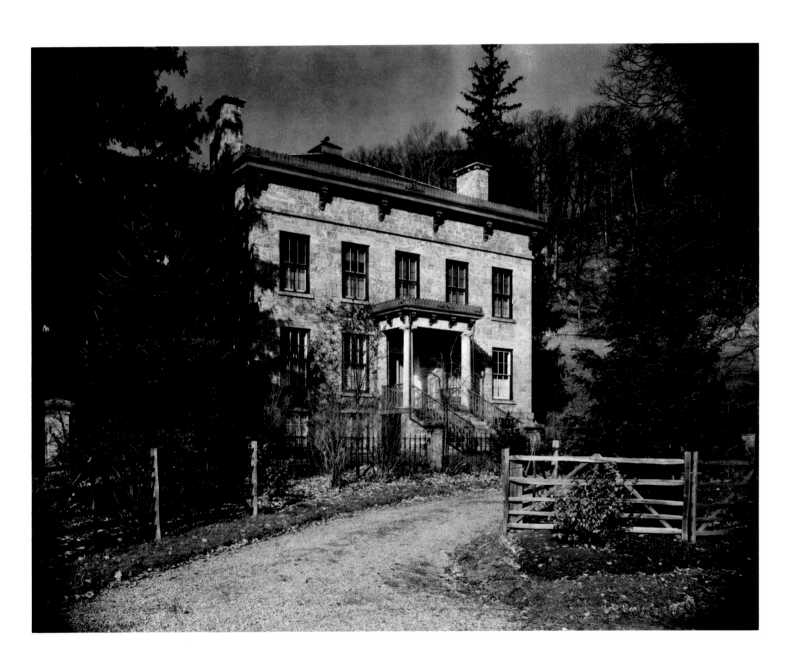

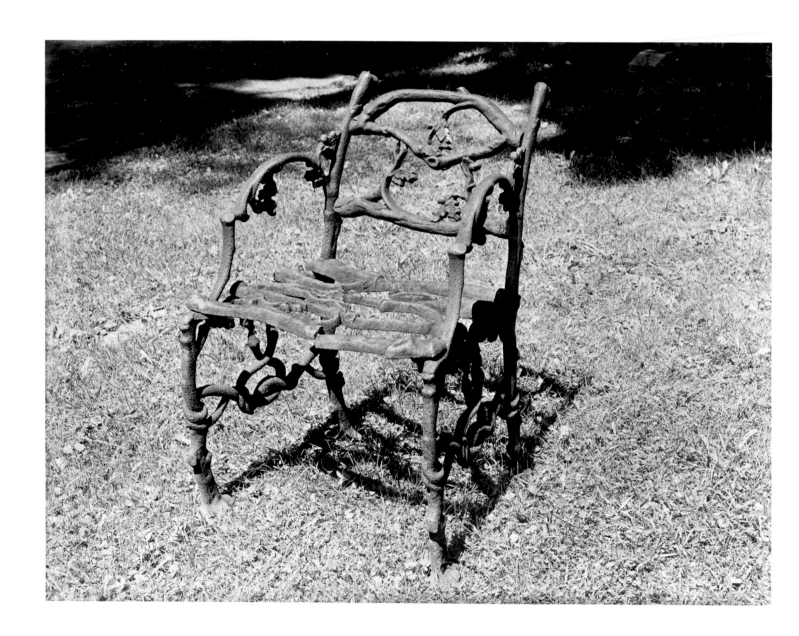

Iron Chair, 1934

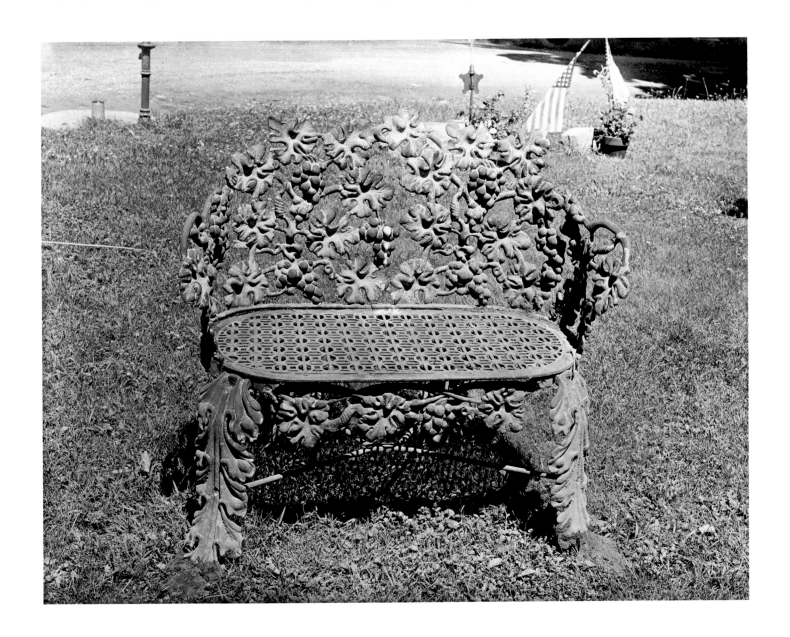

IRON CHAIR, 1934

Interior near Copake, New York, 1933

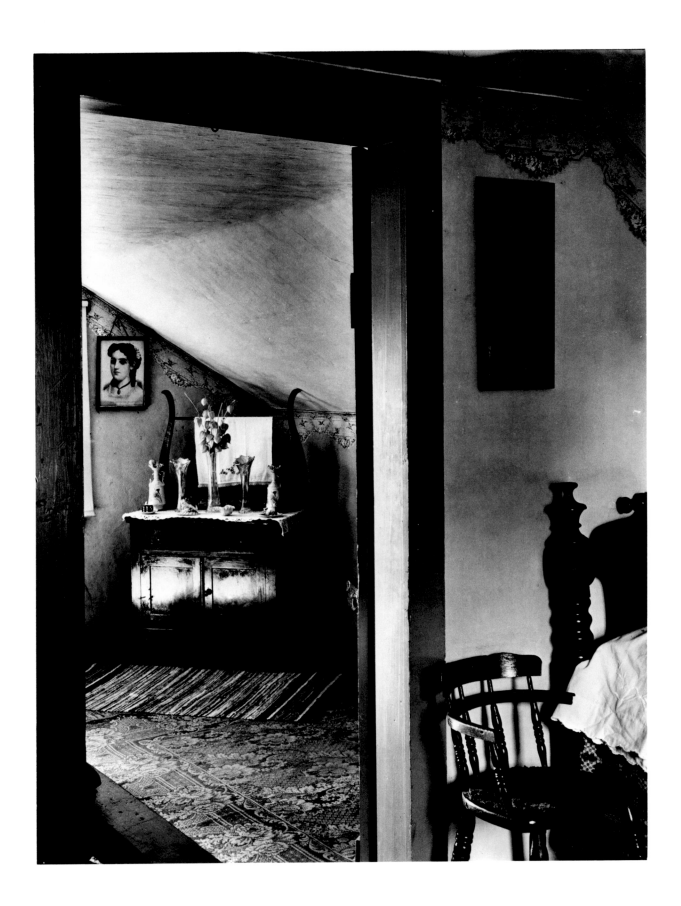

Breakfast Room at Belle Grove Plantation, White Chapel, Louisiana, March 1935

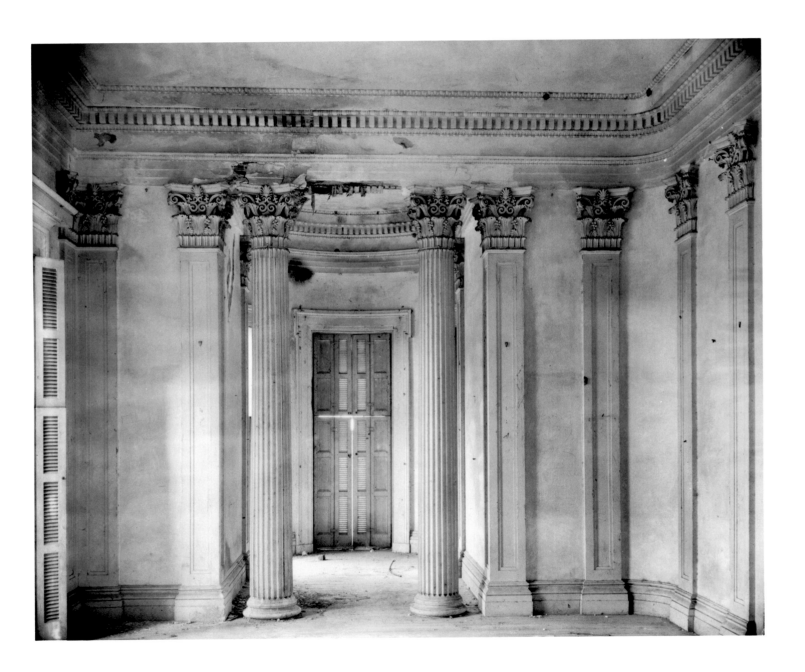

SHARECROPPER'S FAMILY, HALE COUNTY, ALABAMA, 1936

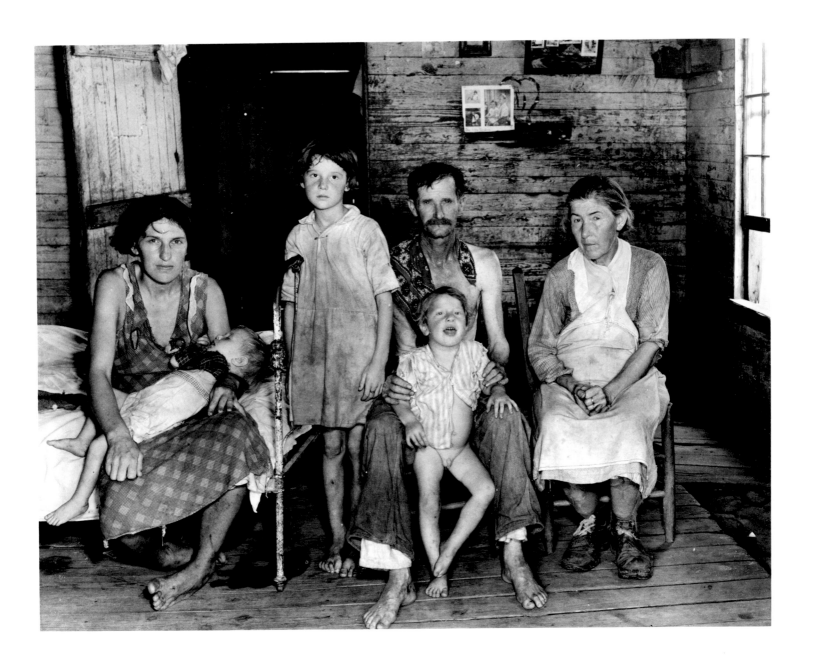

Cabin, Hale County, Alabama, 1936

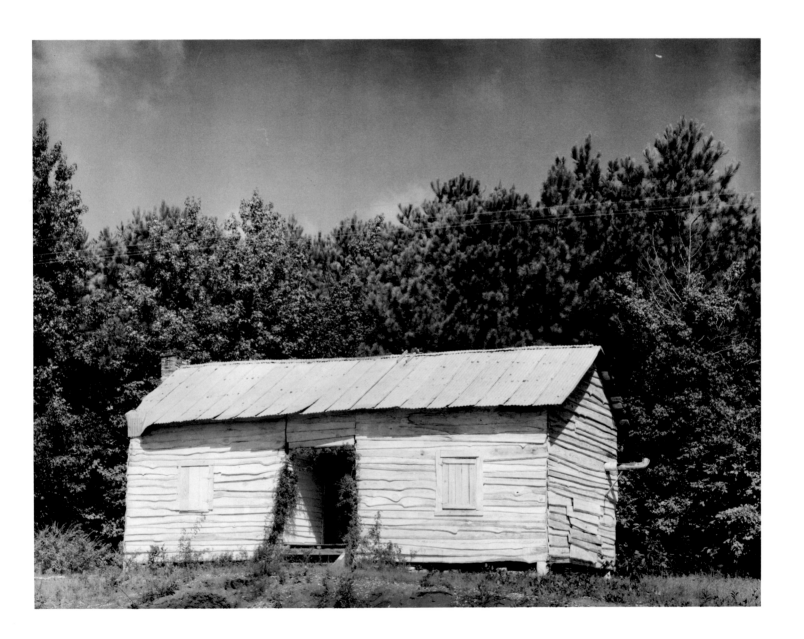

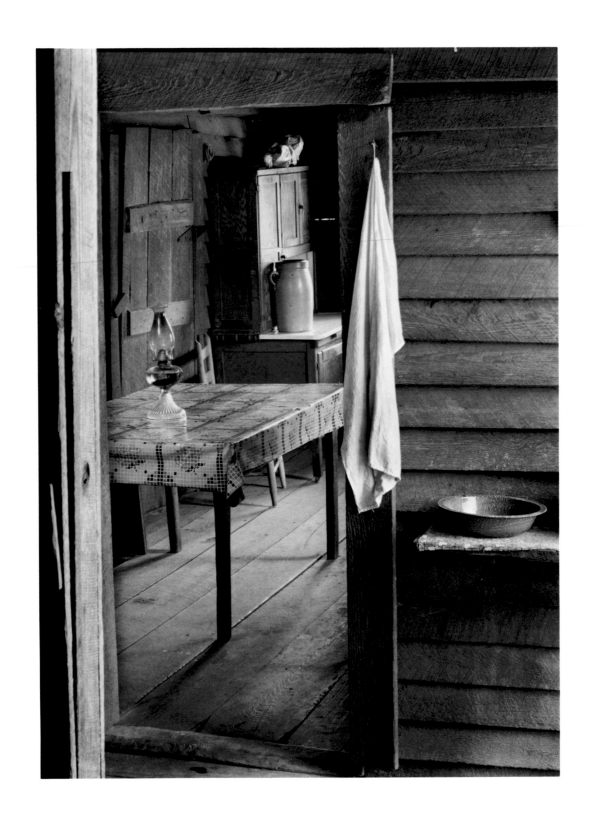

FARMER'S KITCHEN, HALE COUNTY, ALABAMA, 1936

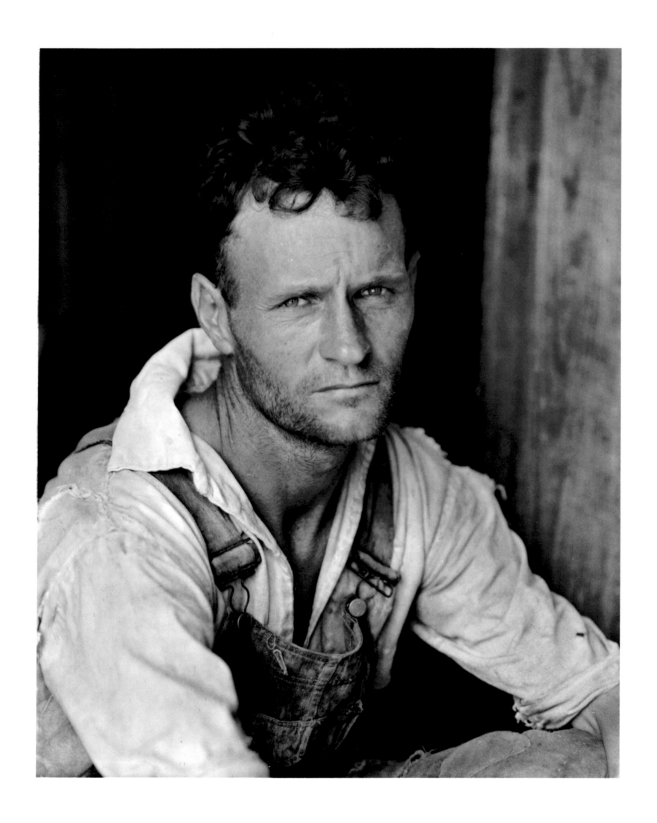

SHARECROPPER, HALE COUNTY, ALABAMA, 1936

POST OFFICE, SPROTT, ALABAMA, 1936

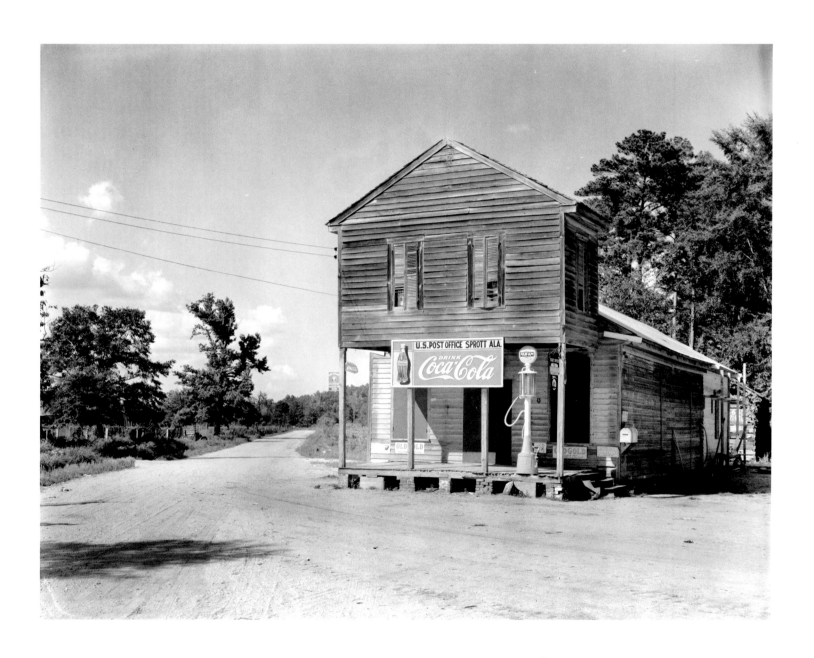

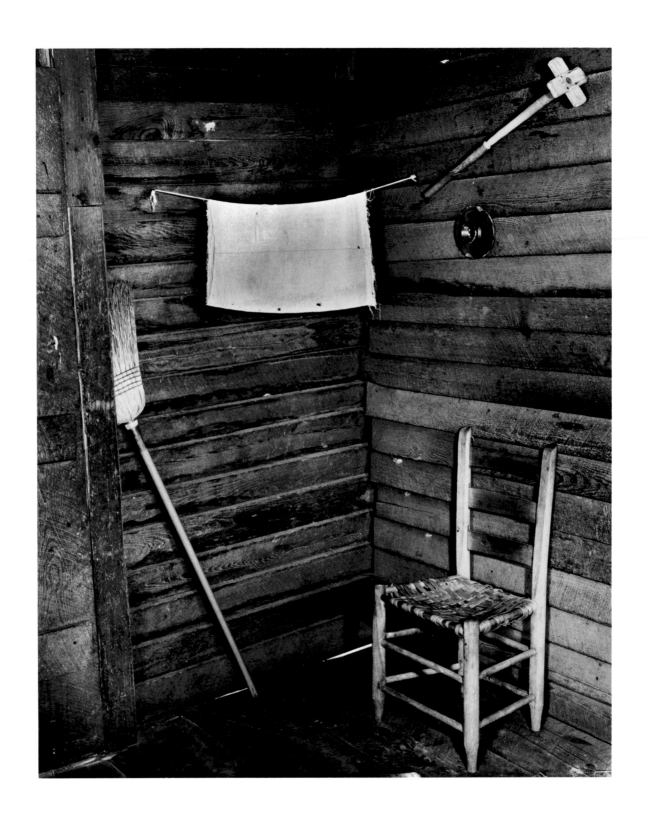

KITCHEN CORNER, TENANT FARMHOUSE, HALE COUNTY, ALABAMA, 1936

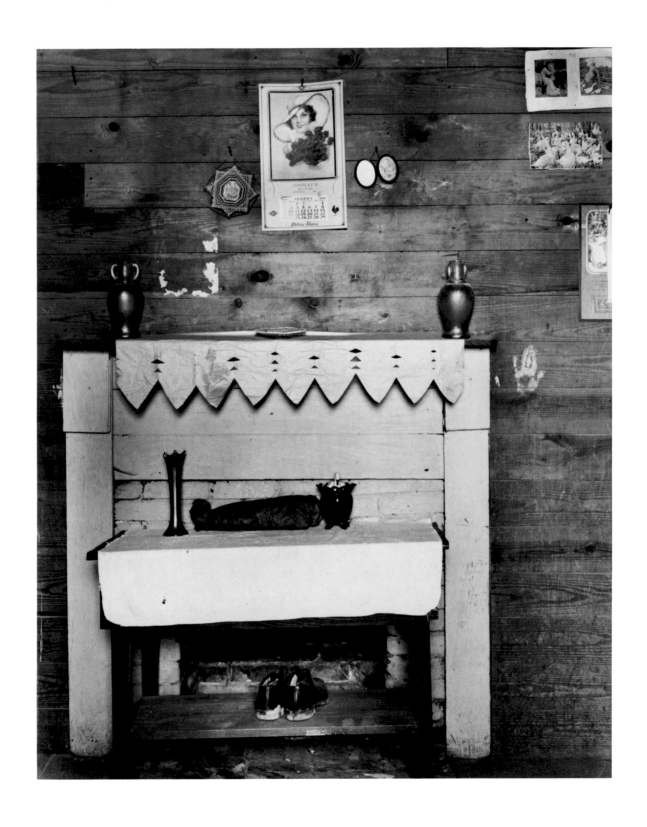

FIREPLACE, TENANT FARMHOUSE, HALE COUNTY, ALABAMA, 1936

Sharecropper's Family, Hale County, Alabama, 1936

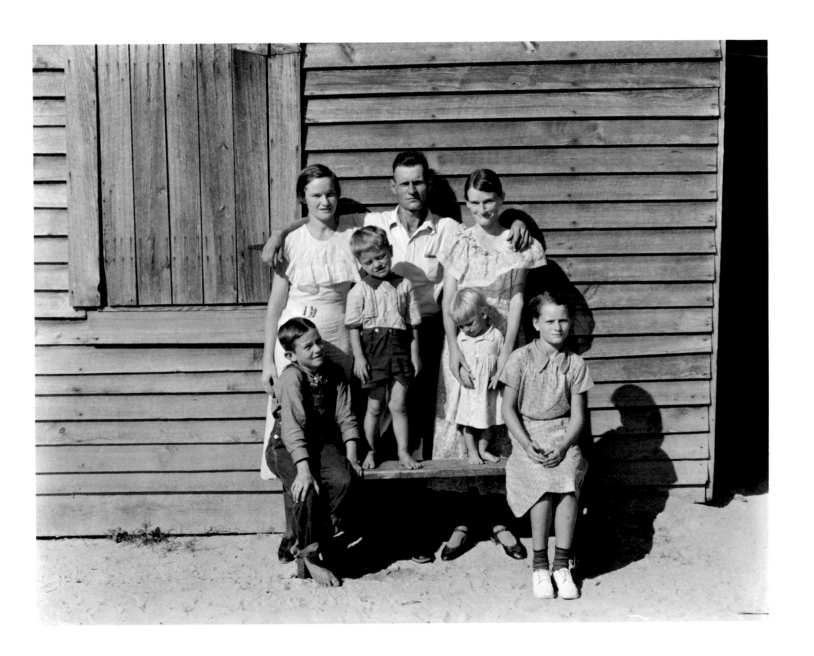

Bucket-Seat Model T, Alabama Town, 1936

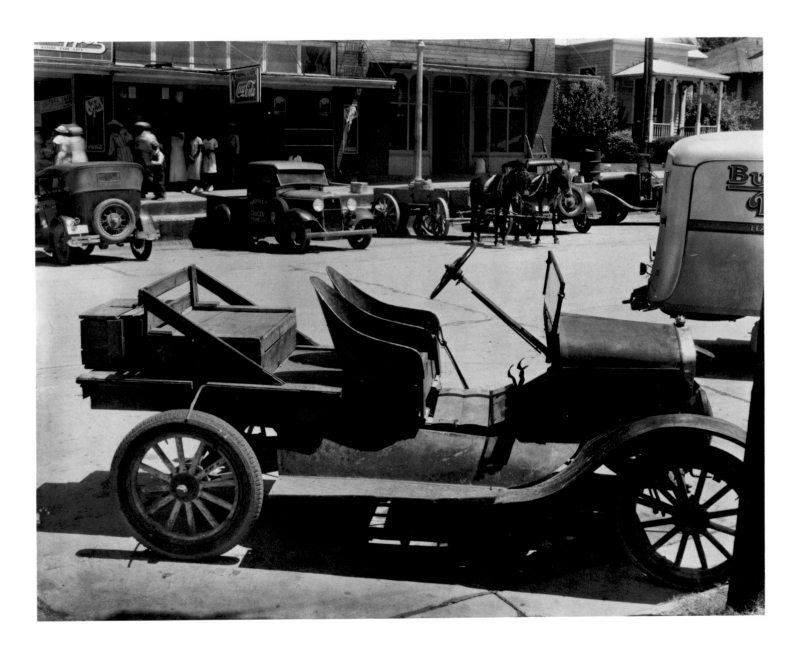

SHARECROPPER, HALE COUNTY, ALABAMA, 1936

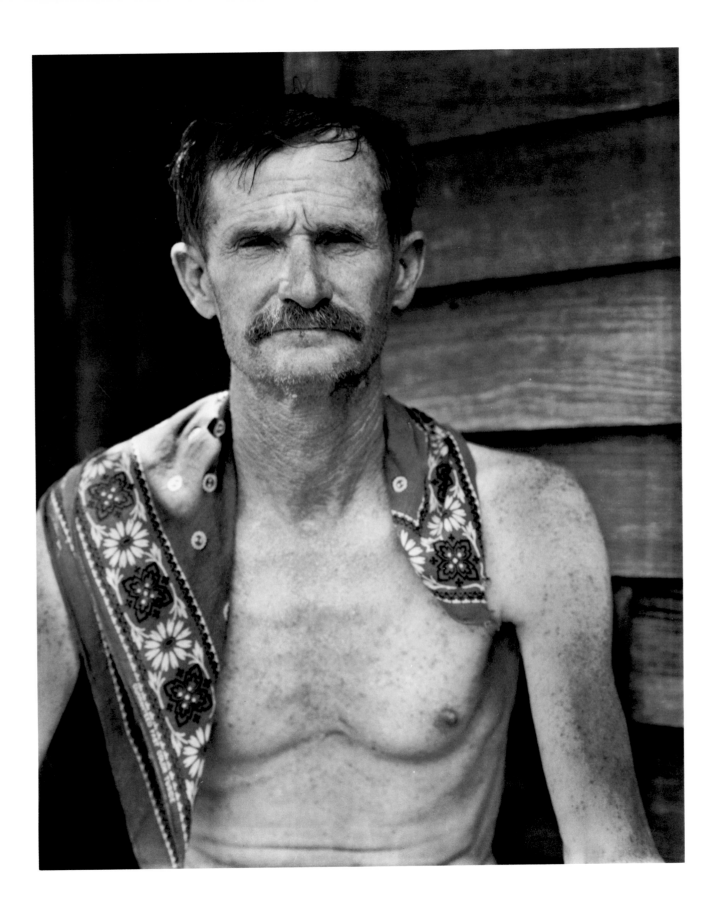

BED, TENANT FARMHOUSE, HALE COUNTY, ALABAMA, 1936

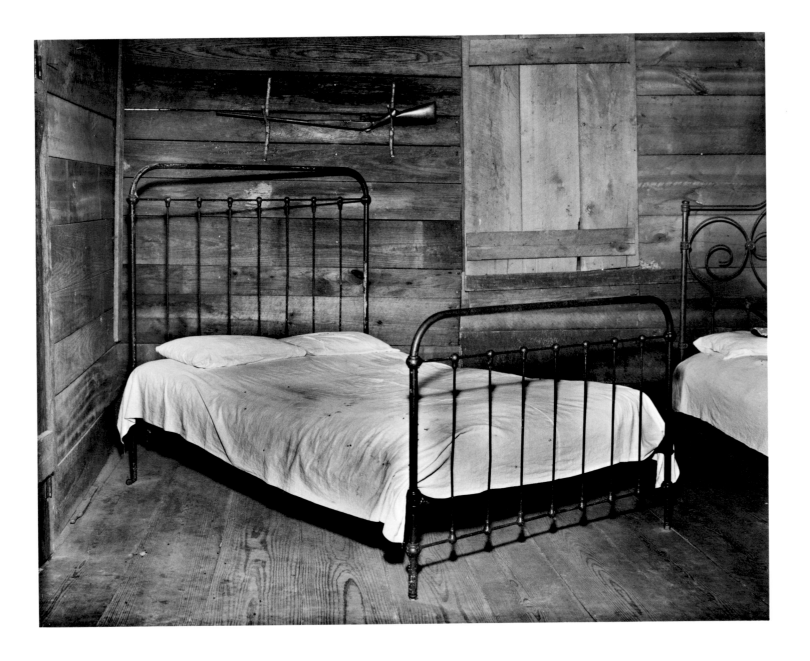

Sharecropper's Wife, Hale County, Alabama, 1936

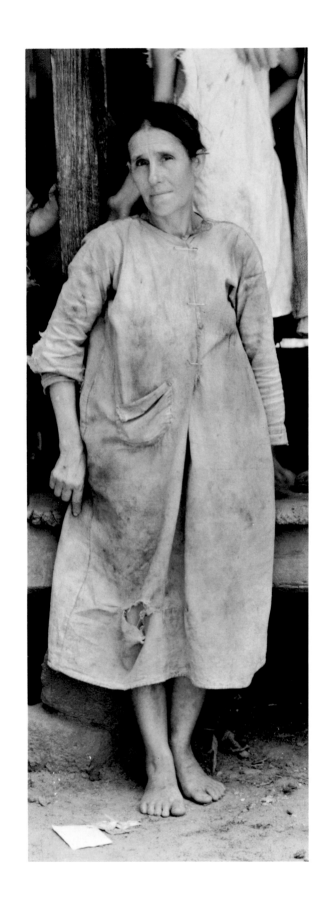

SCHOOL WITH SEPARATE BELL, ALABAMA, 1936

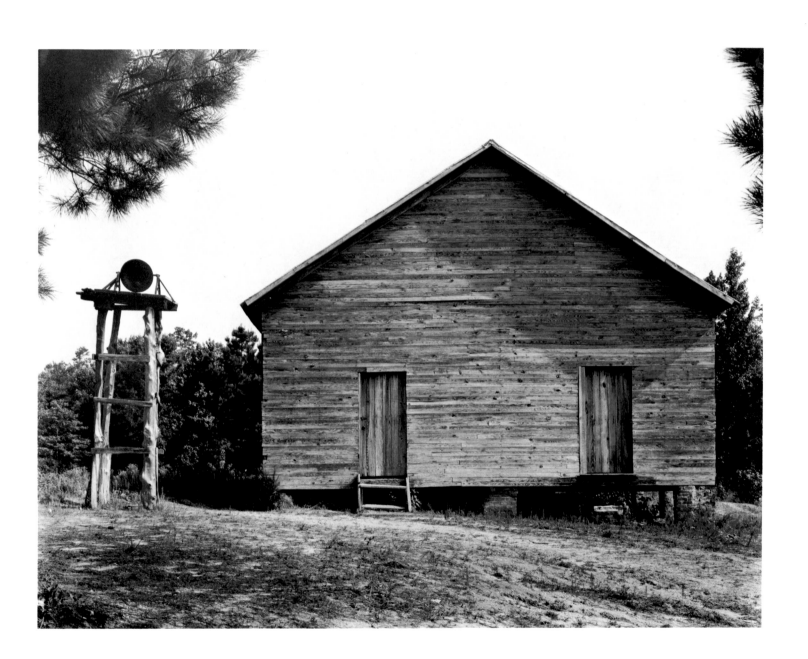

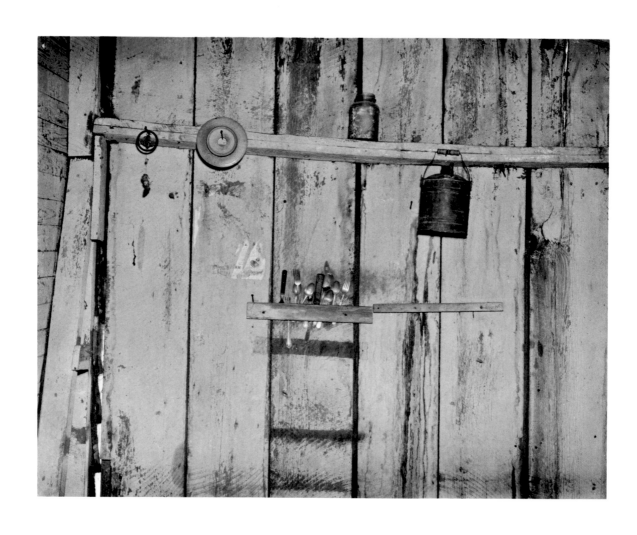

KITCHEN WALL, ALABAMA FARMSTEAD, 1936

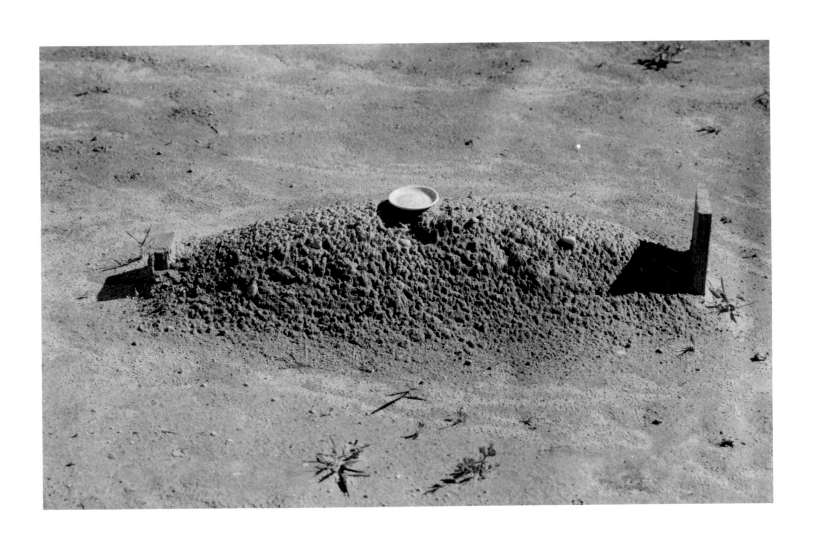

CHILD'S GRAVE, HALE COUNTY, ALABAMA, 1936

CORRUGATED TIN FAÇADE, 1936

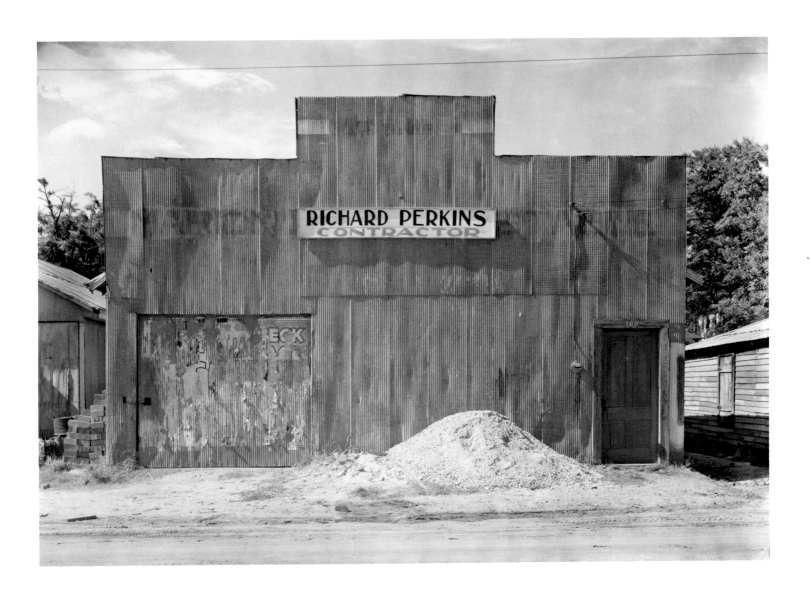

TUSCALOOSA WRECKING COMPANY, ALABAMA, 1936

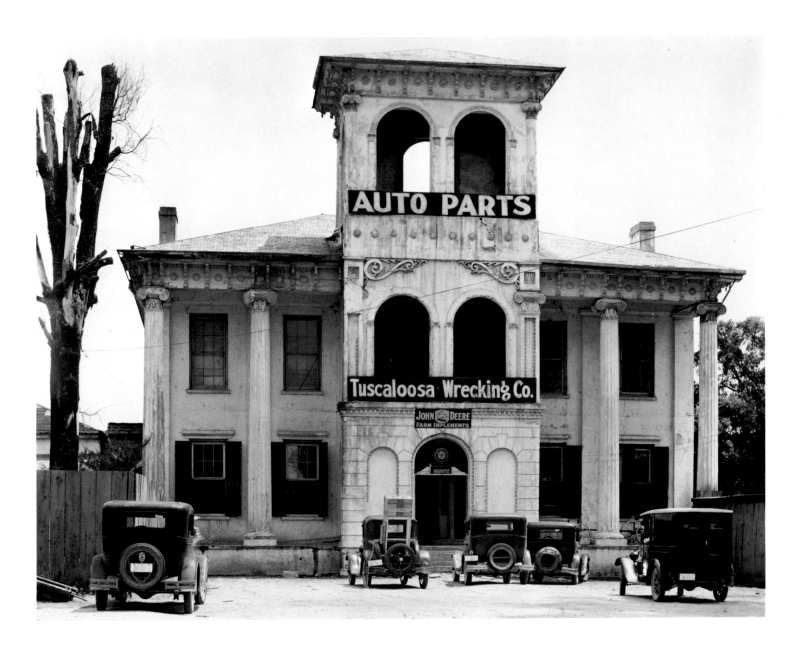

Store Building, Vicksburg, Mississippi, 1936

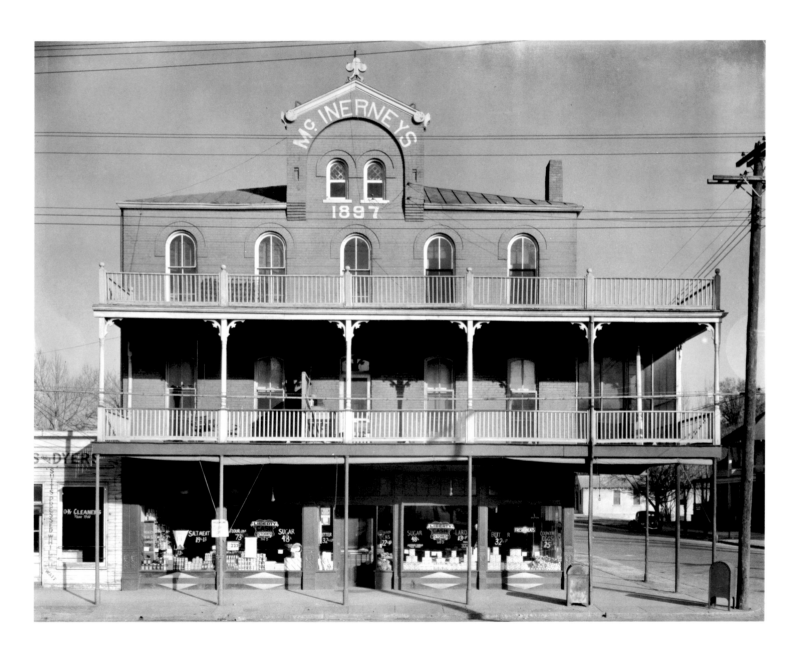

SELMA, ALABAMA, 1936

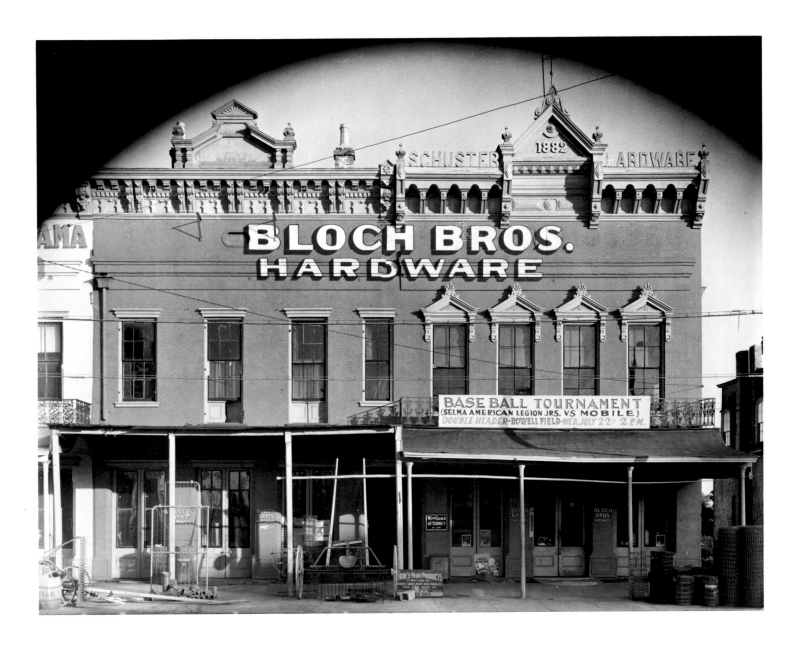

Hardware Store, Southern Town, 1936

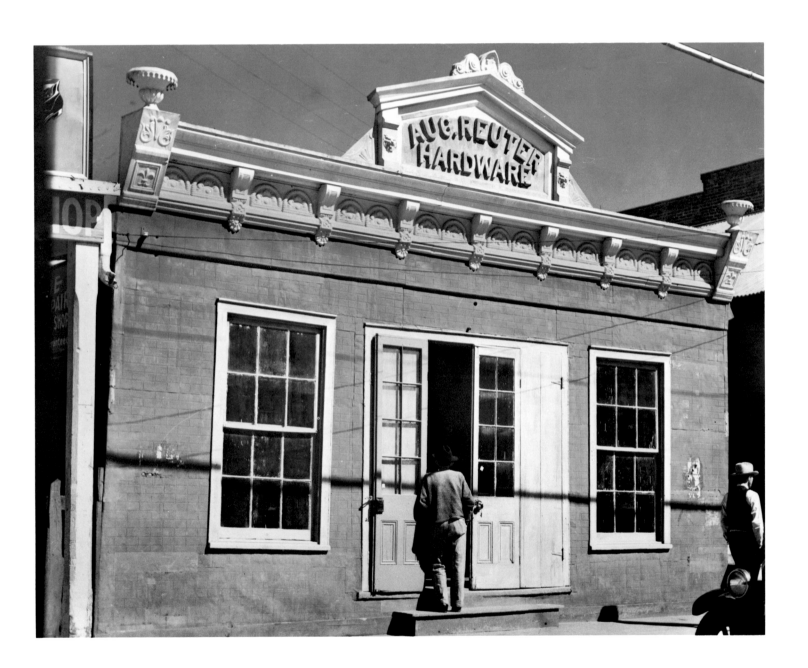

COMPANY STORE, HECLA, WEST VIRGINIA, 1936

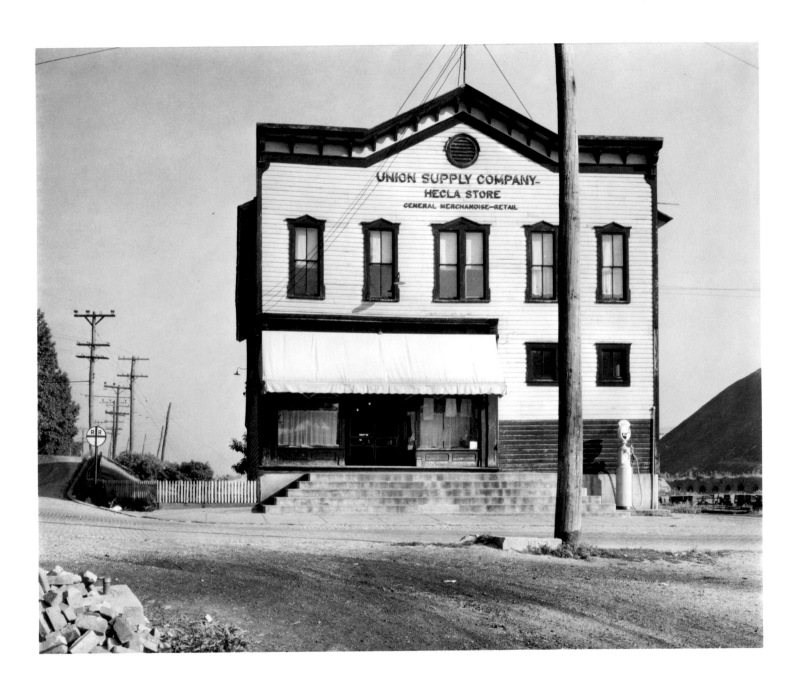

113

ROADSIDE STORE BETWEEN TUSCALOOSA AND GREENSBORO, ALABAMA, 1936

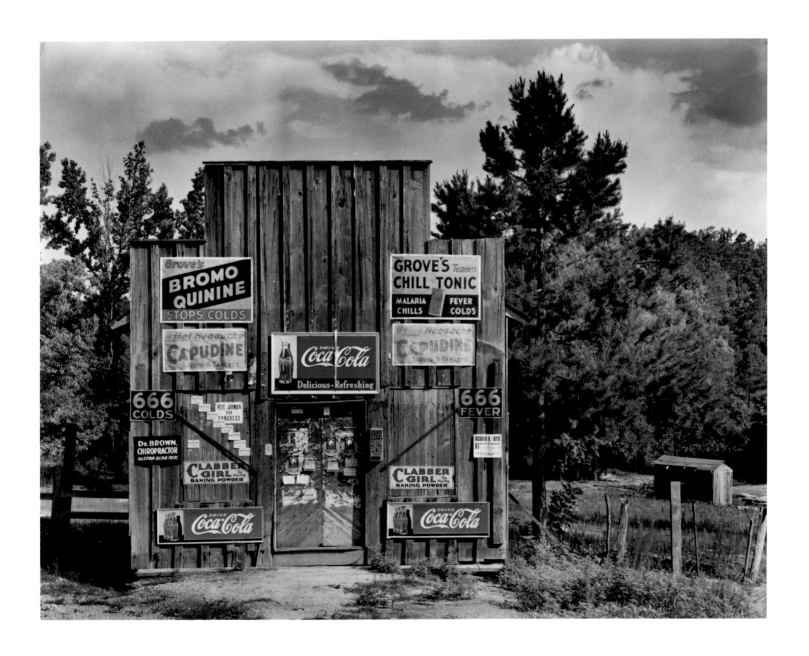

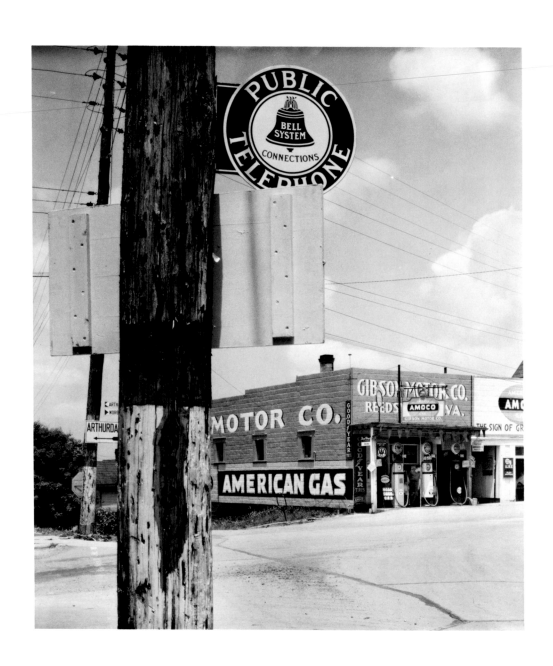

GAS STATION, REEDSVILLE, WEST VIRGINIA, 1936

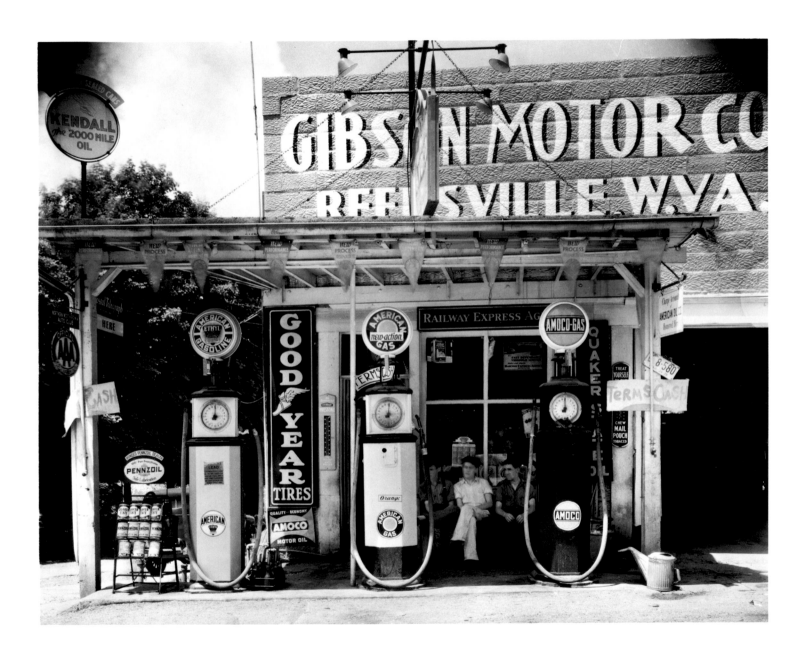

GAS STATION, REEDSVILLE, WEST VIRGINIA, 1936

Mining Town, West Virginia, 1936

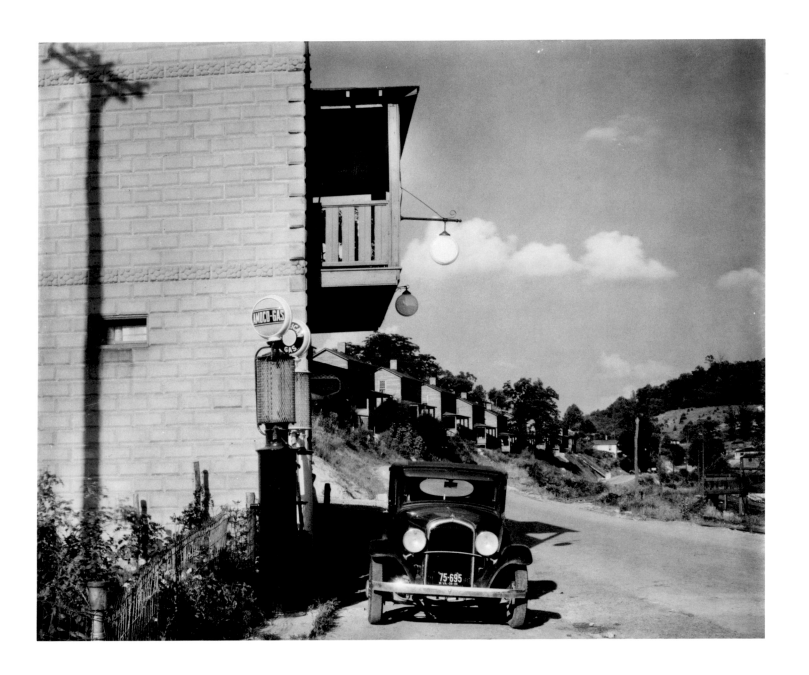

119

ABANDONED BUILDINGS, HALE COUNTY, ALABAMA, 1936

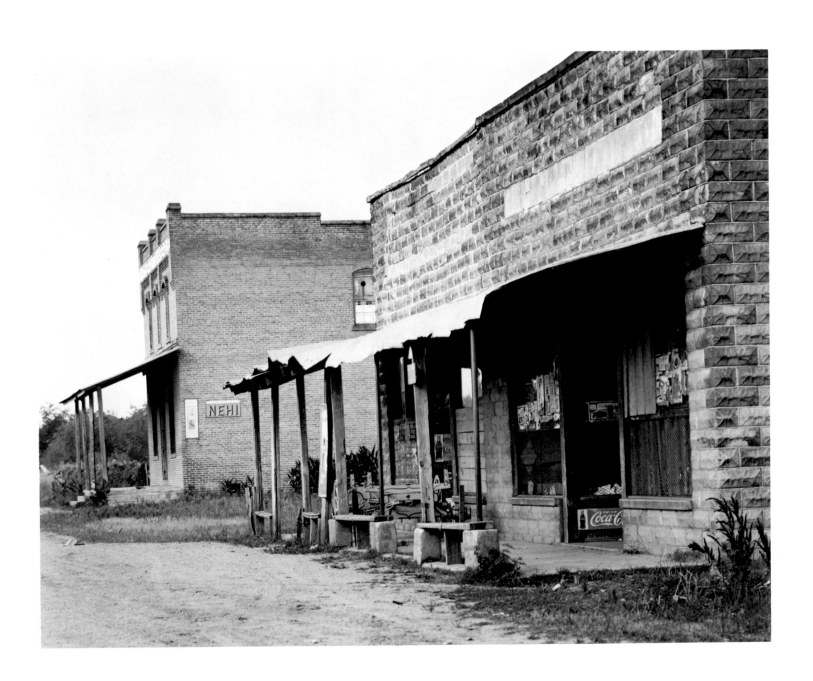

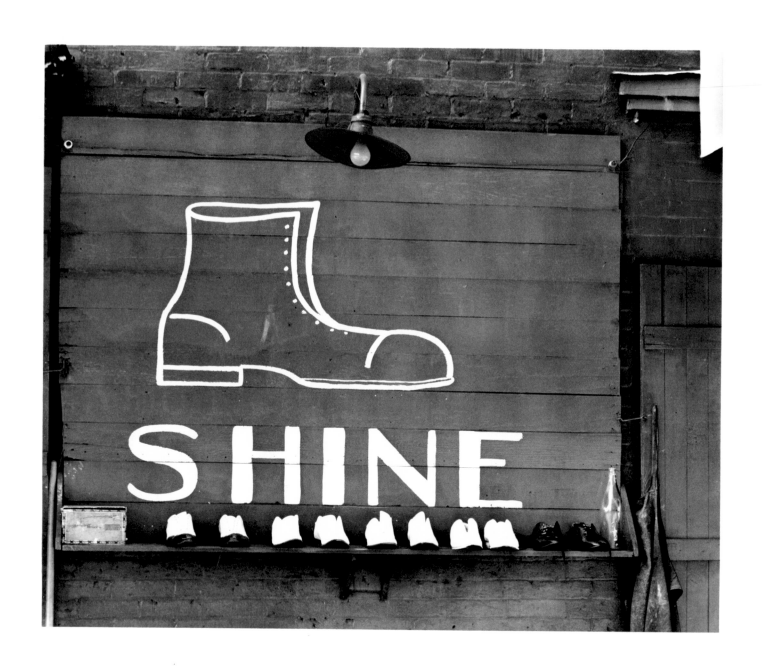

Shoeshine Sign in a Southern Town, 1936

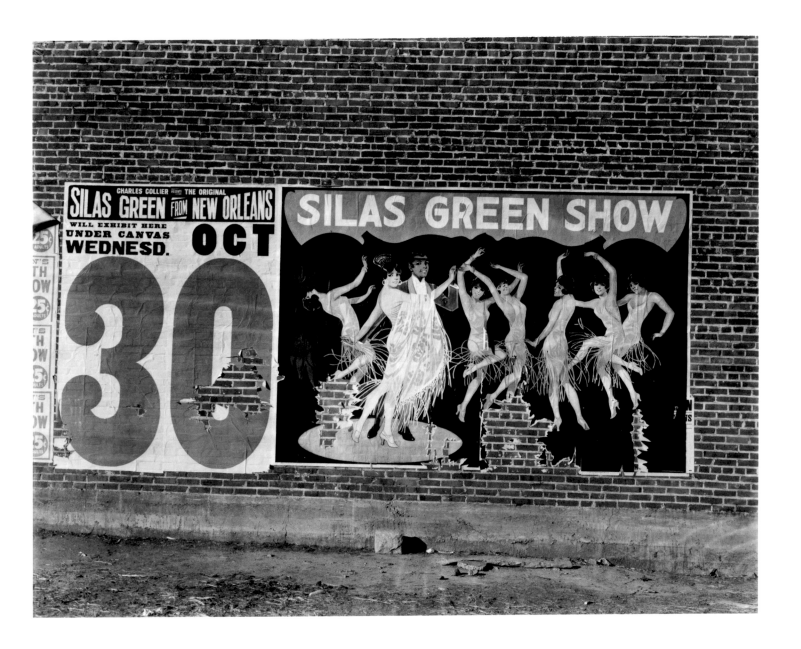

SHOW BILL, DEMOPOLIS, ALABAMA, 1936

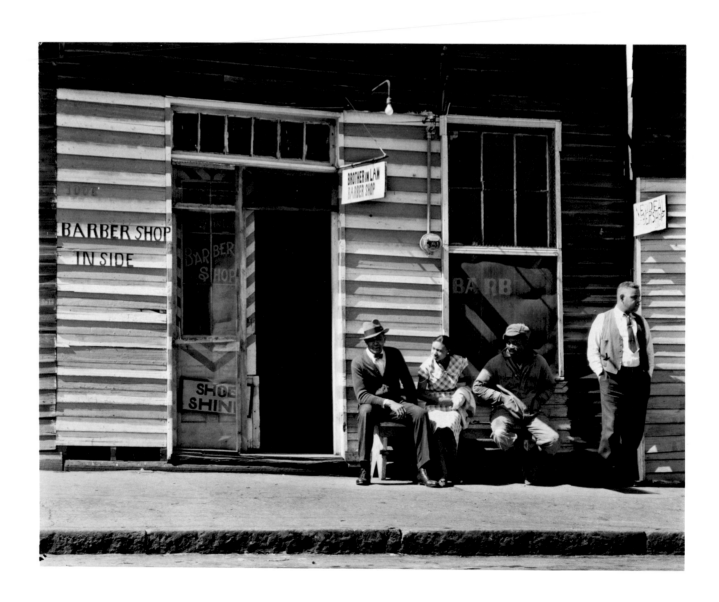

BARBER SHOP, SOUTHERN TOWN, 1936

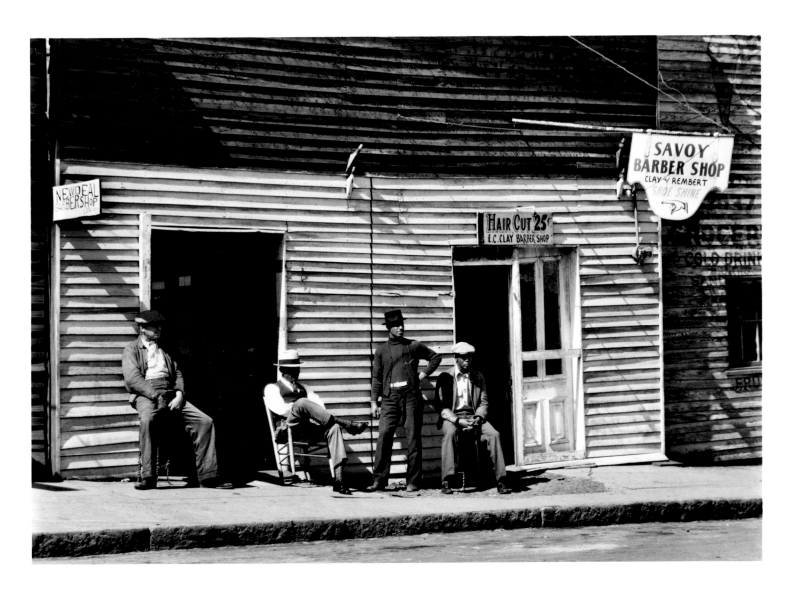

BARBER SHOP, SOUTHERN TOWN, 1936

COAL MINER'S HOUSE, SCOTT'S RUN, WEST VIRGINIA, 1936

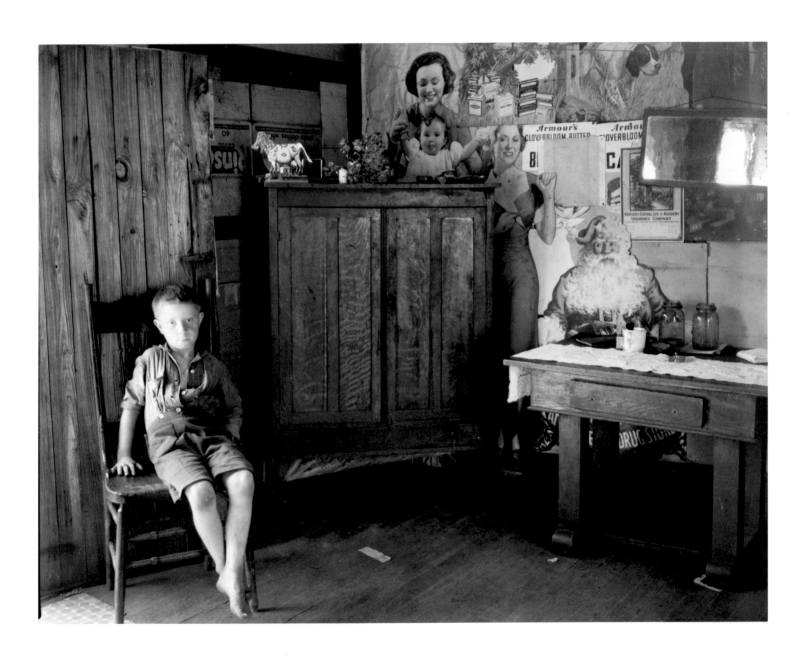

SIGNS, SOUTH CAROLINA, 1936

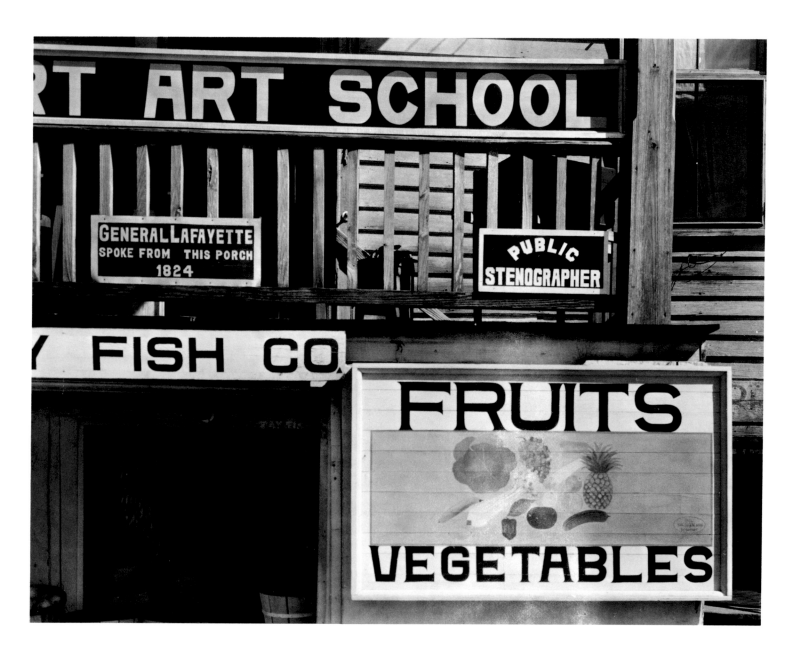

STAR PRESSING CLUB, VICKSBURG, MISSISSIPPI, 1936

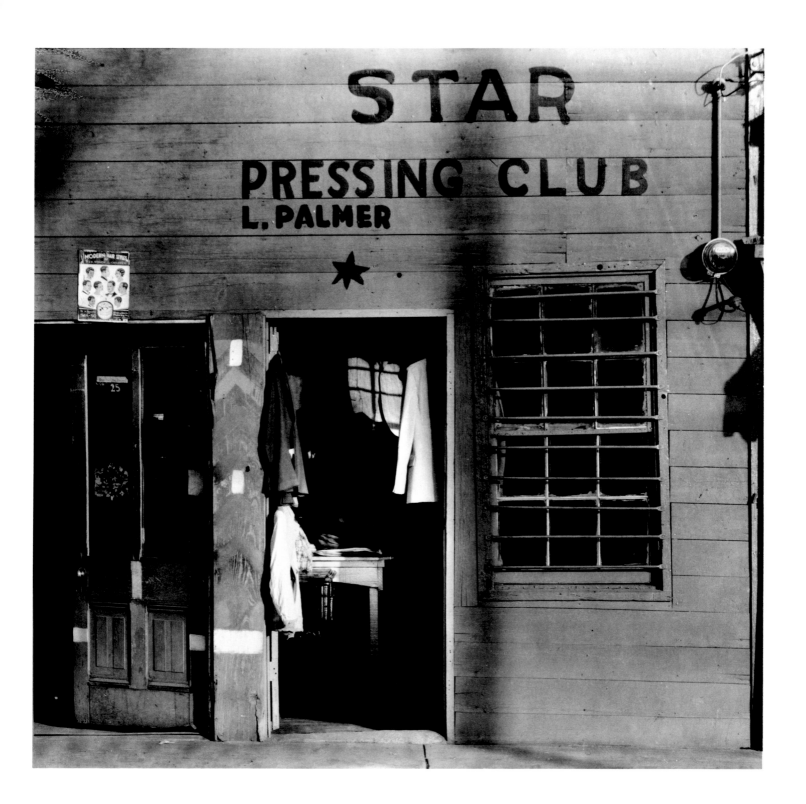

OUTDOOR ADVERTISING SIGN NEAR BATON ROUGE, LOUISIANA, 1935

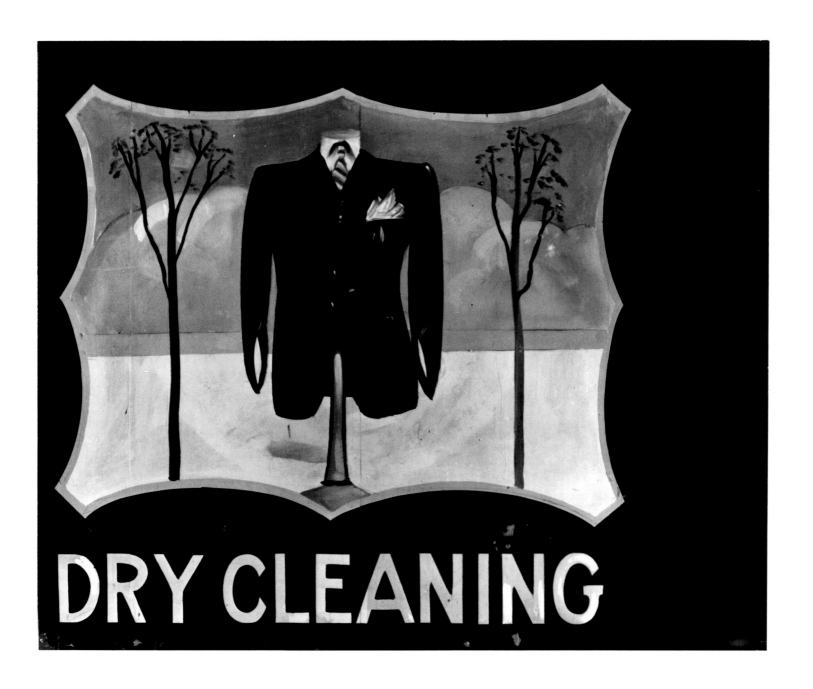

DRY CLEANING

BILLBOARD PAINTERS, FLORIDA, CA. 1934

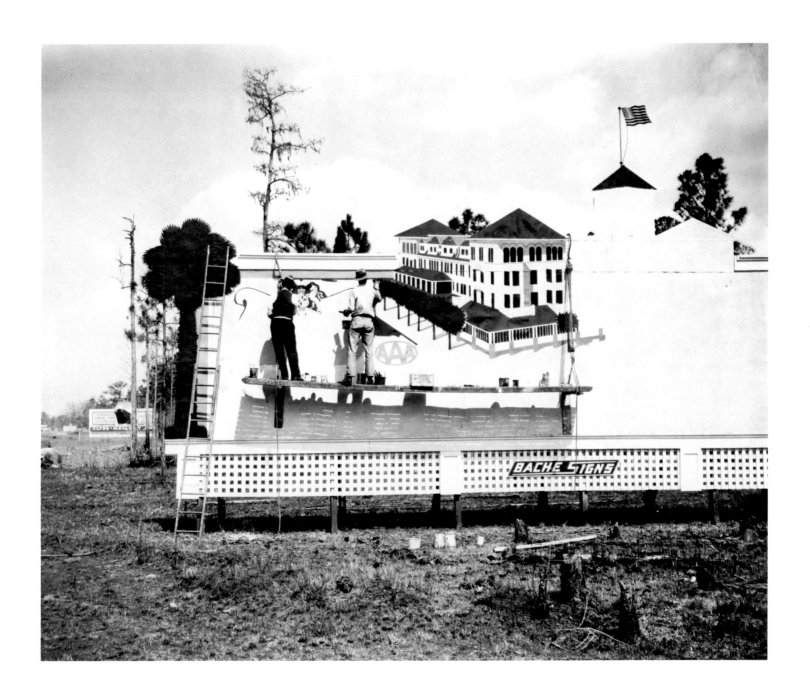

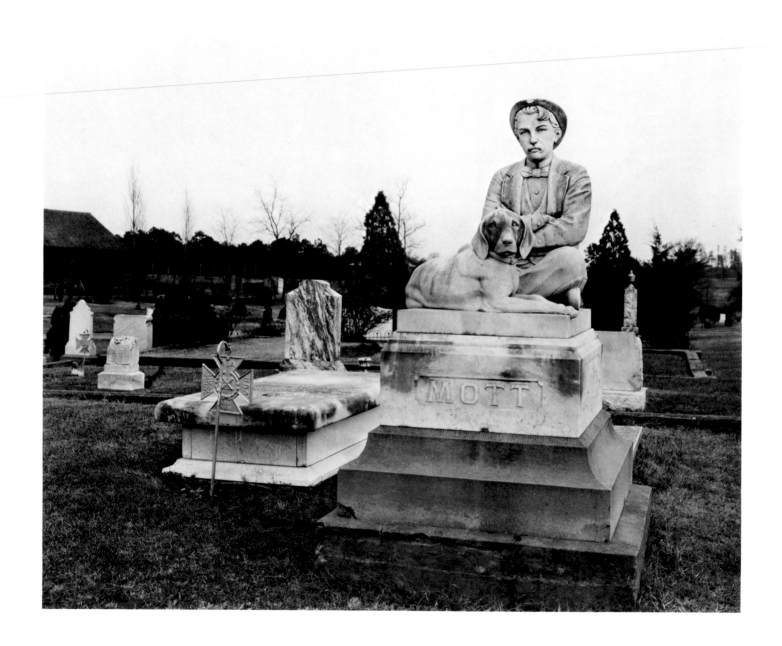

GRAVESTONE, LOUISIANA, 1935

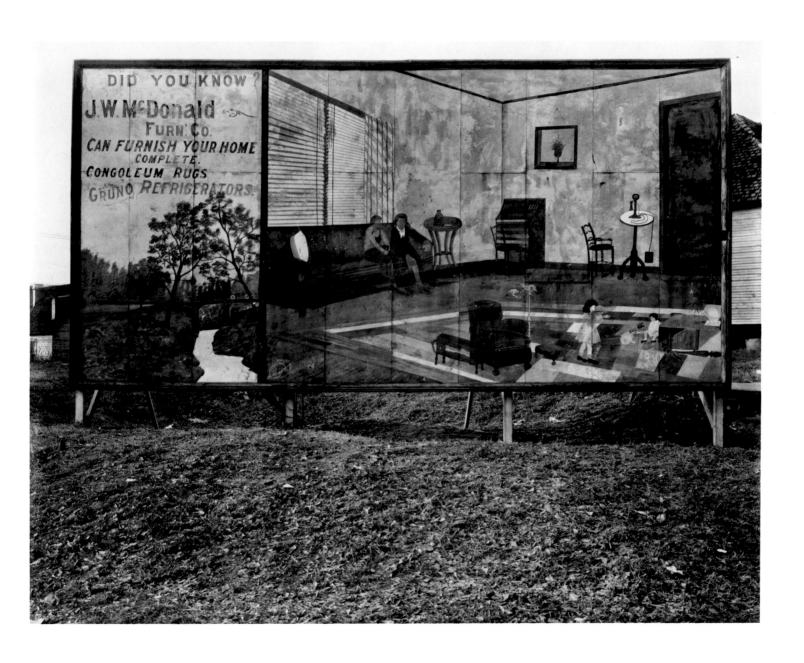

FURNITURE STORE SIGN NEAR BIRMINGHAM, ALABAMA, 1936 137

PHILLIPSBURG, NEW JERSEY, 1935

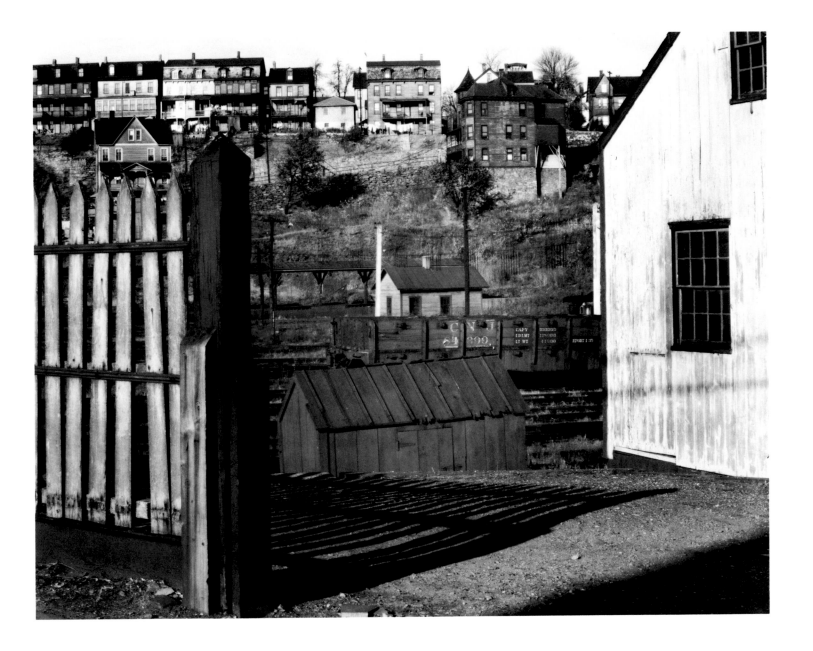

EASTON, PENNSYLVANIA, 1936

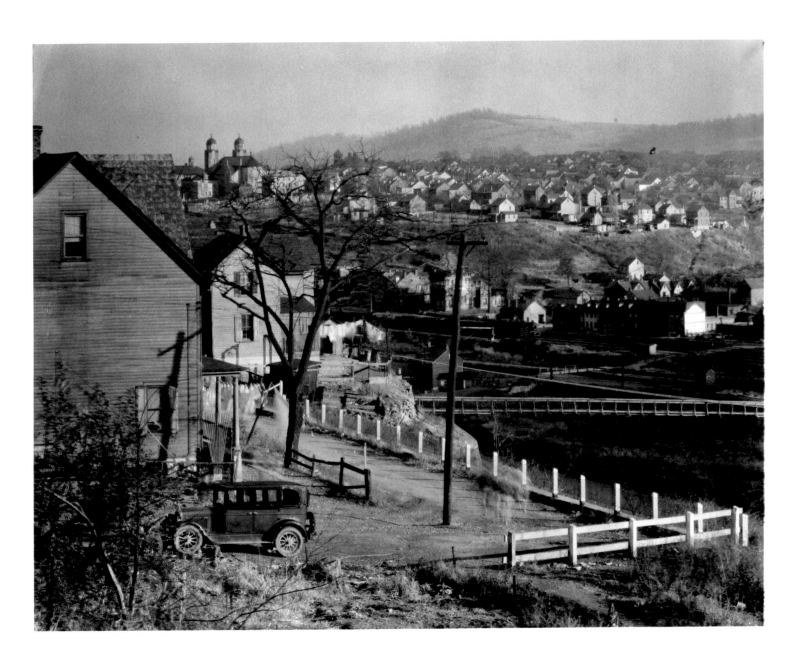

BETHLEHEM, PENNSYLVANIA, 1936

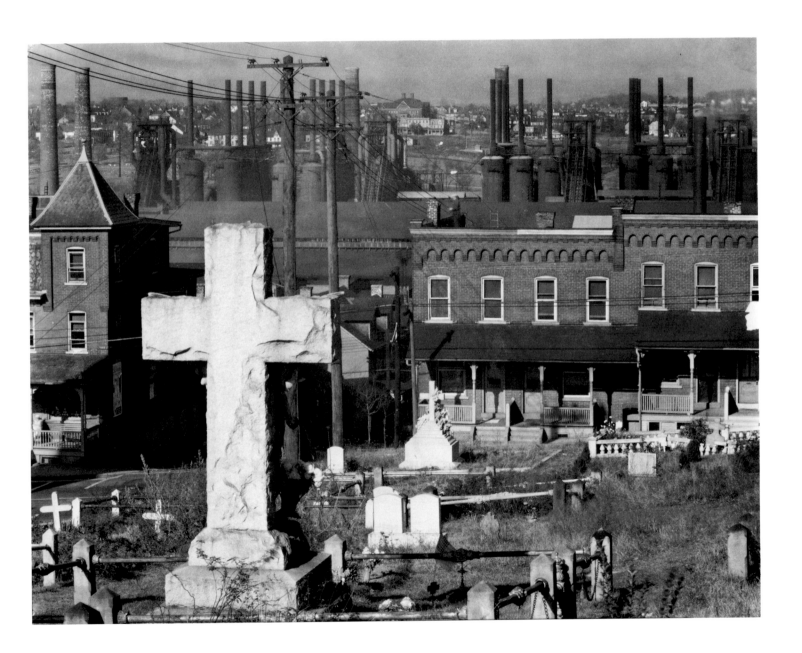

LANDSCAPE, GULF COAST, LOUISIANA, 1935

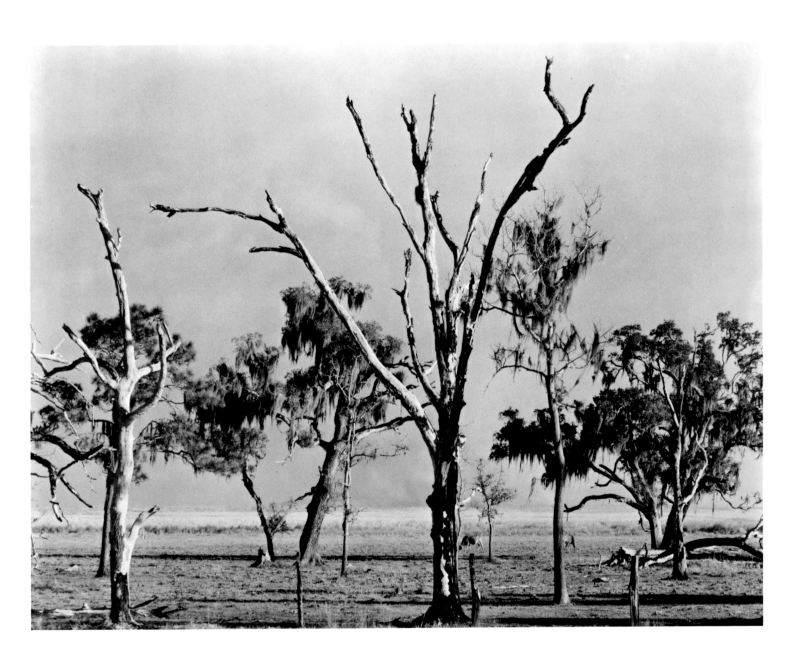

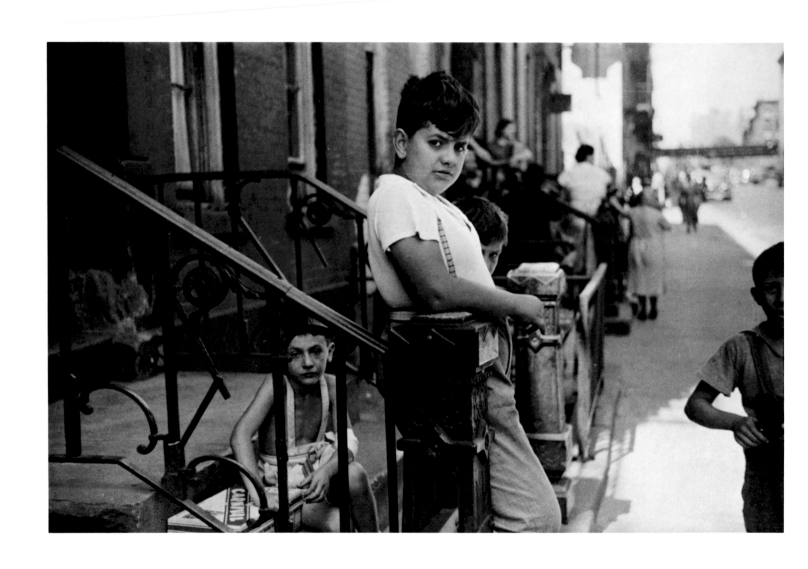

STREET SCENE, NEW YORK, 1936

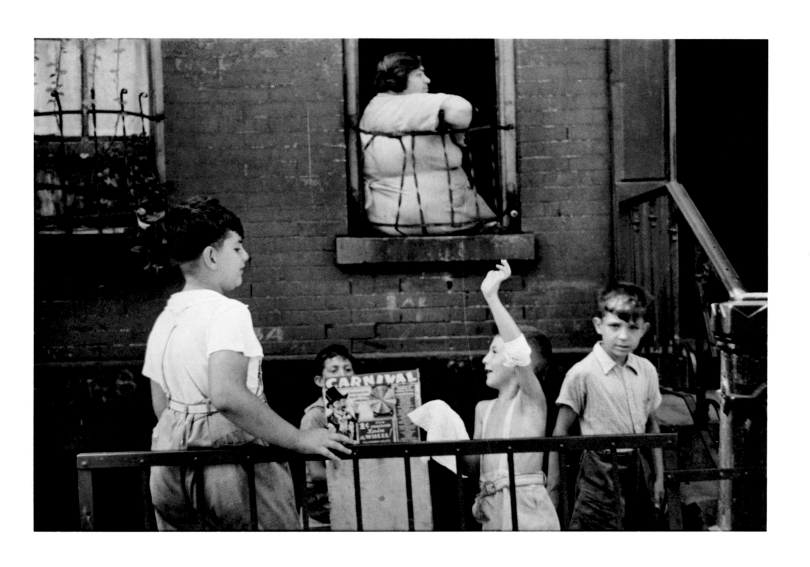

STREET SCENE, NEW YORK, 1936

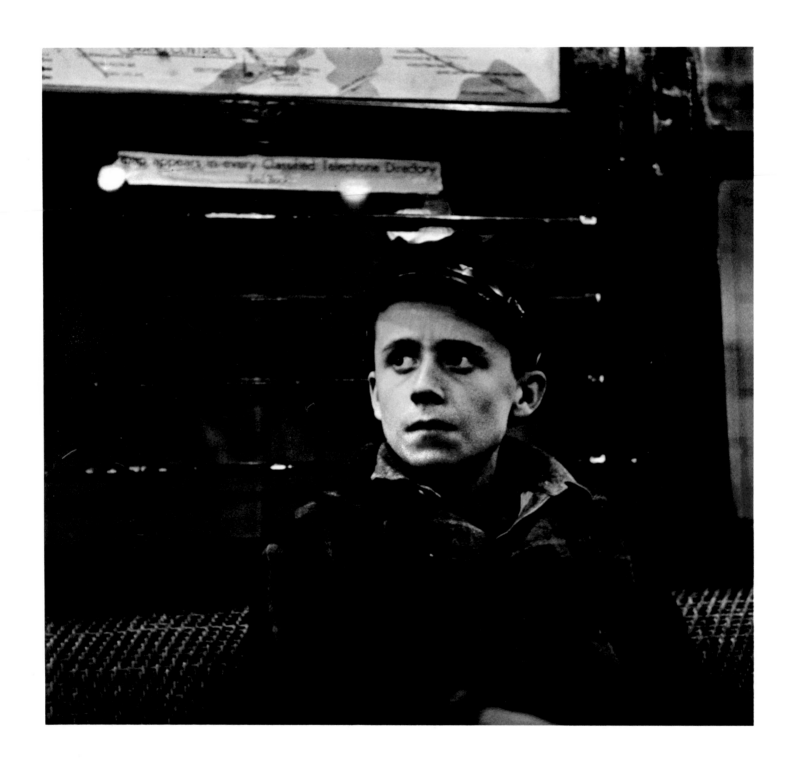

Subway Portrait, 1941

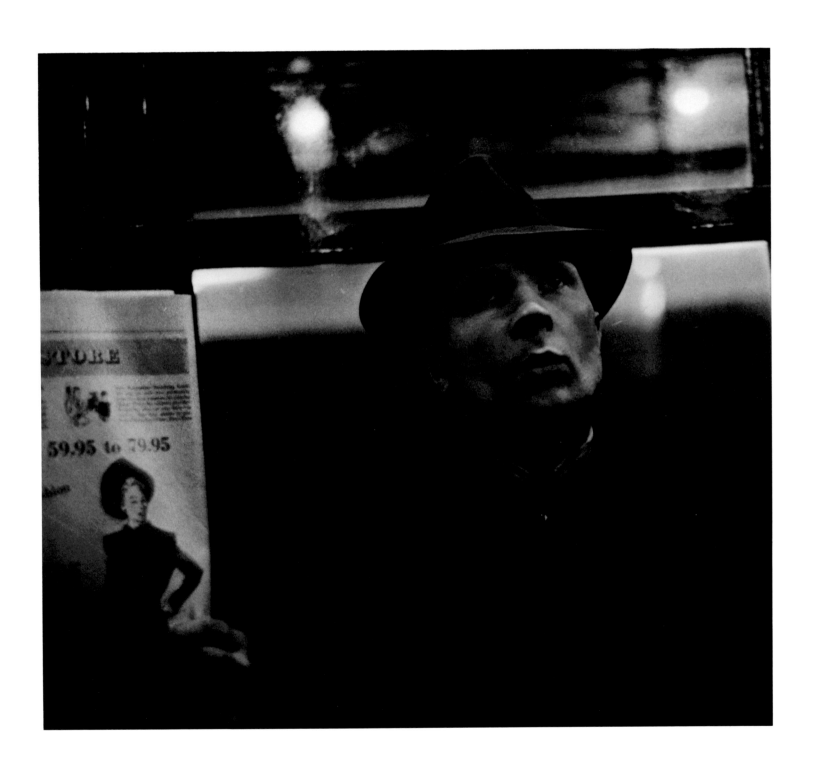

SUBWAY PORTRAIT, 1941

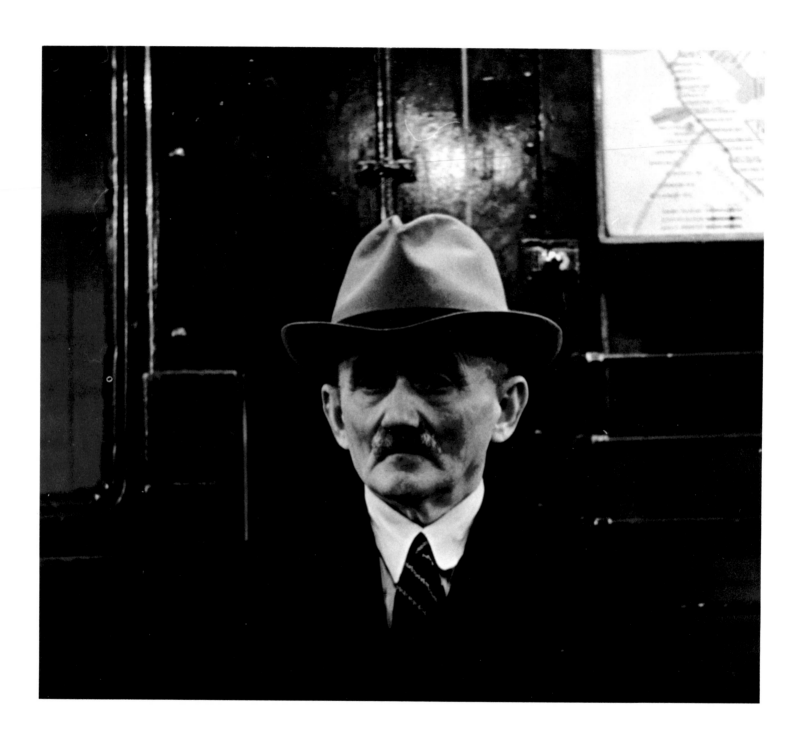

150 SUBWAY PORTRAIT, 1941

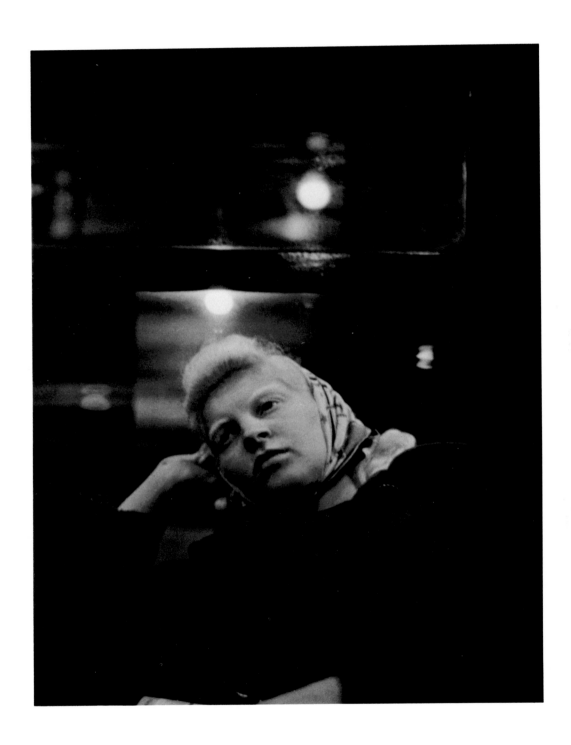

SUBWAY PORTRAIT, 1941 151

BEDROOM DRESSER, SHRIMP FISHERMAN'S HOUSE, BILOXI, MISSISSIPPI, 1945

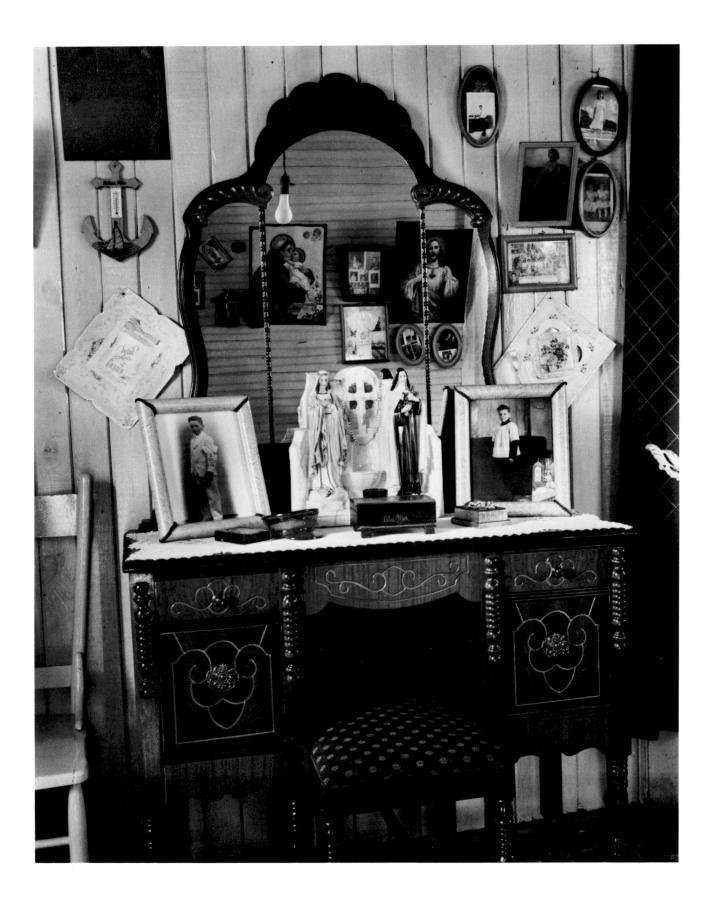

BEDROOM, SHRIMP FISHERMAN'S HOUSE, BILOXI, MISSISSIPPI, 1945

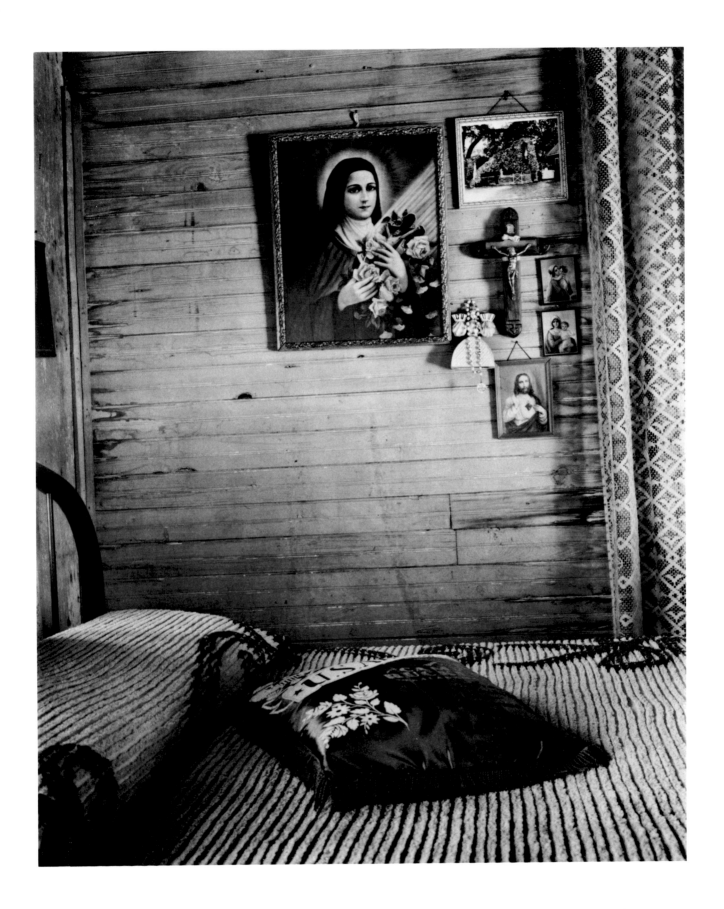

Bedroom, Shrimp Fisherman's House, Biloxi, Mississippi, 1945

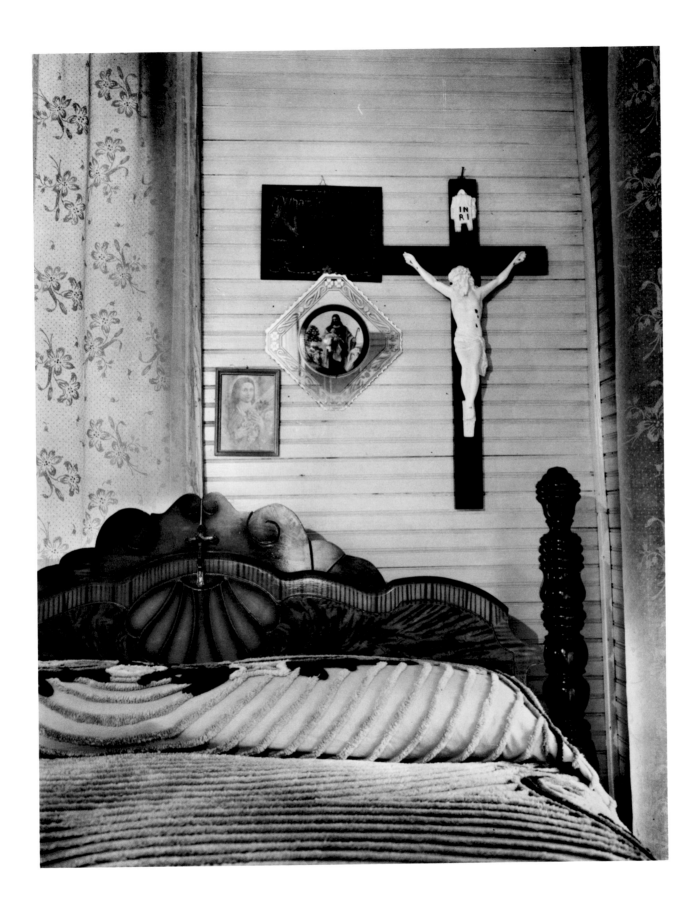

Street Musician, Chicago, n.d.

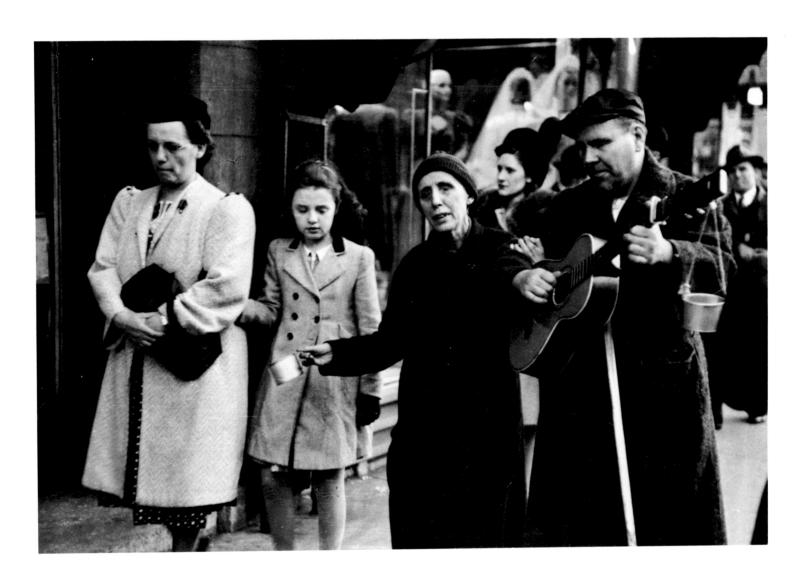

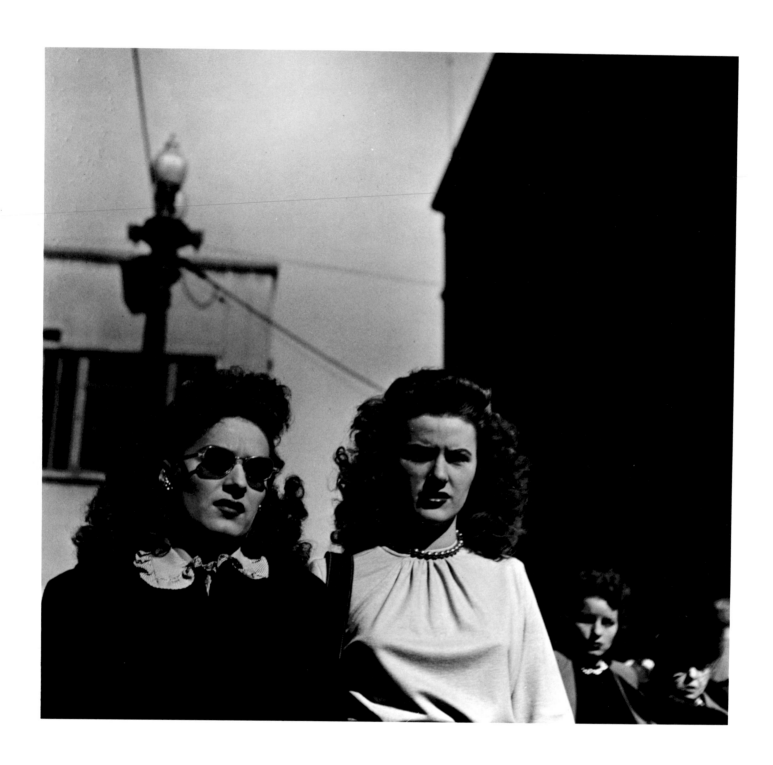

160 Corner of State and Randolph Streets, Chicago, 1946

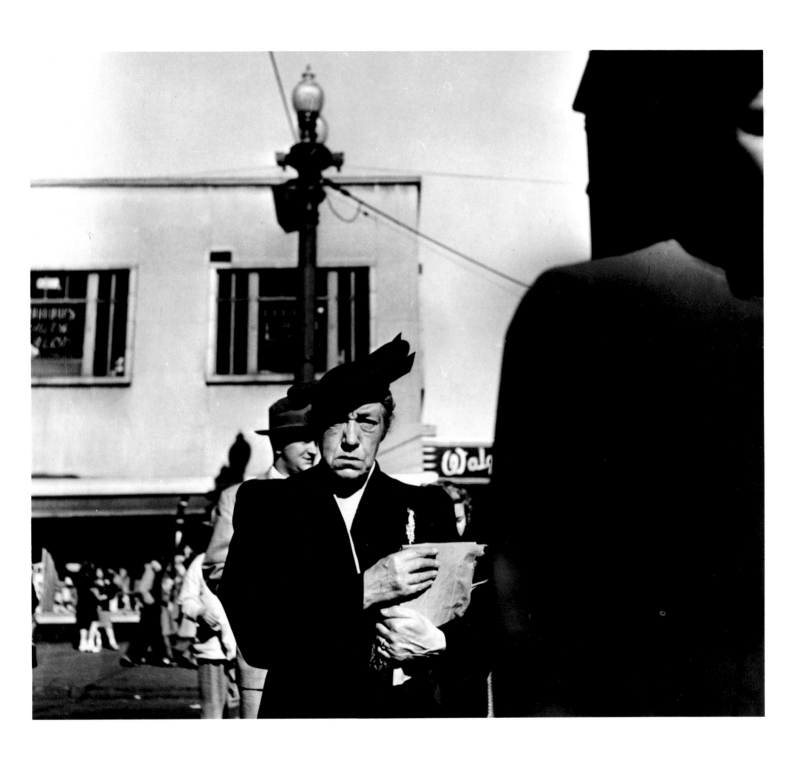

CORNER OF STATE AND RANDOLPH STREETS, CHICAGO, 1946 161

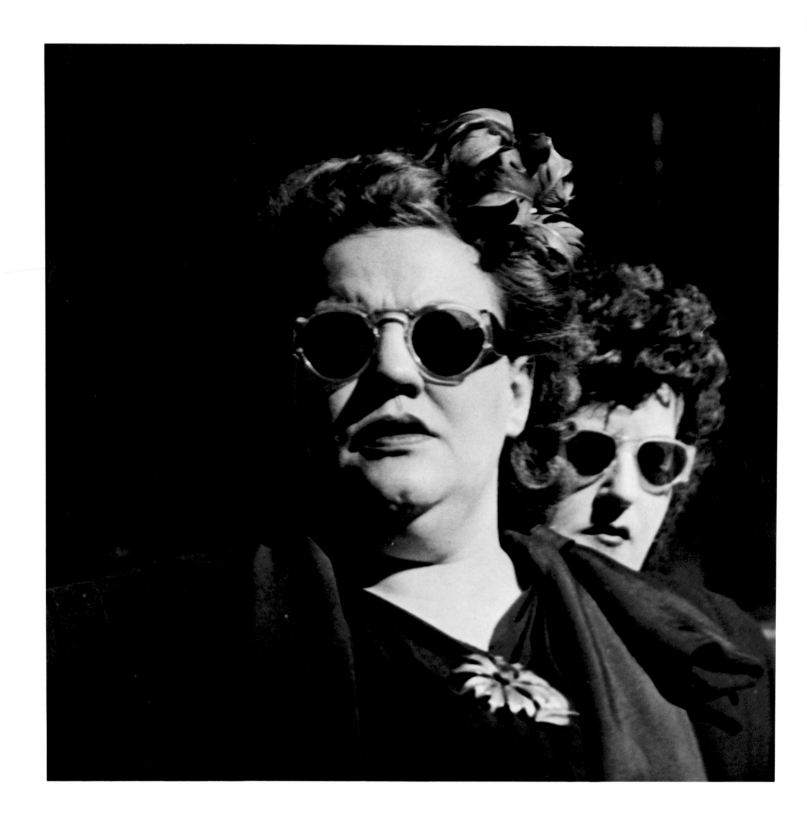

SHOPPERS, RANDOLPH STREET, CHICAGO, 1947

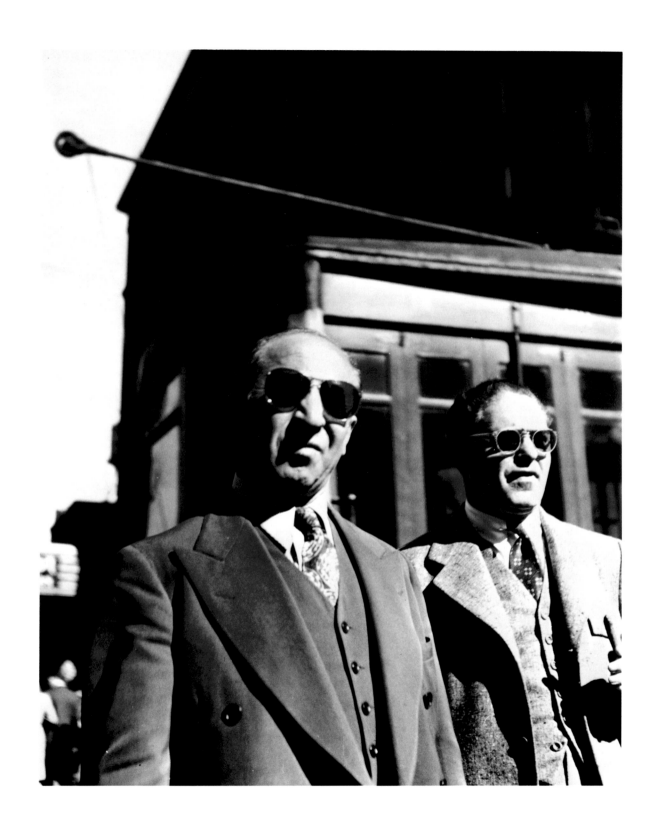

CORNER OF STATE AND RANDOLPH STREETS, CHICAGO, 1946

Trash Can, New York, ca. 1968

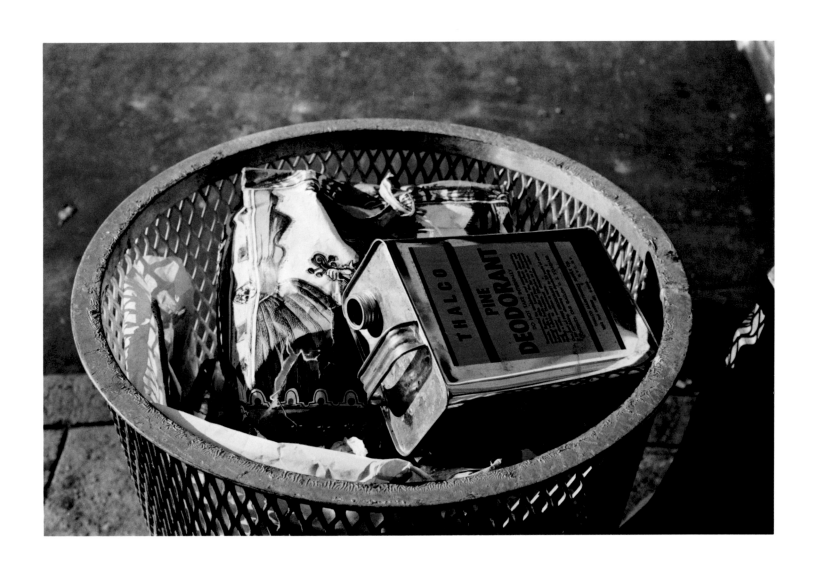

BAGGAGE WAGONS, GALENA, ILLINOIS, 1947

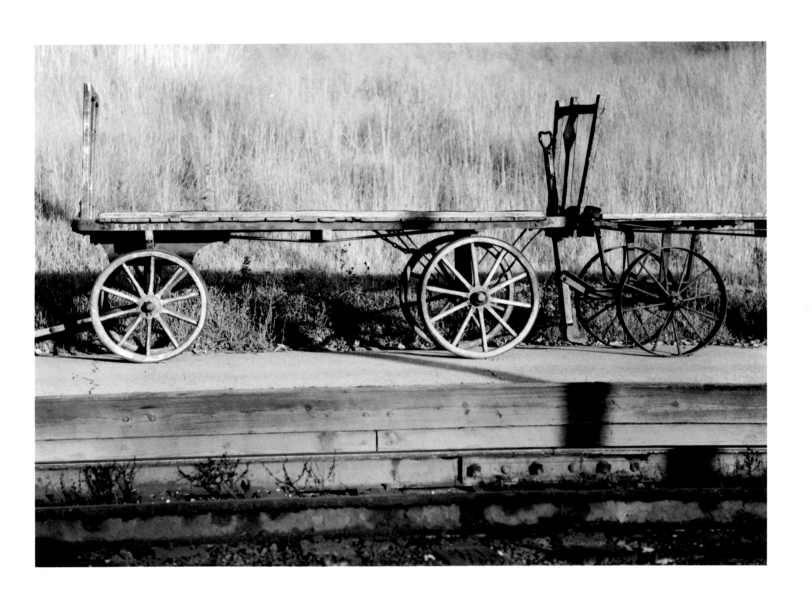

THE CHILD'S ROOM, STOCKBRIDGE, MASSACHUSETTS, 1951

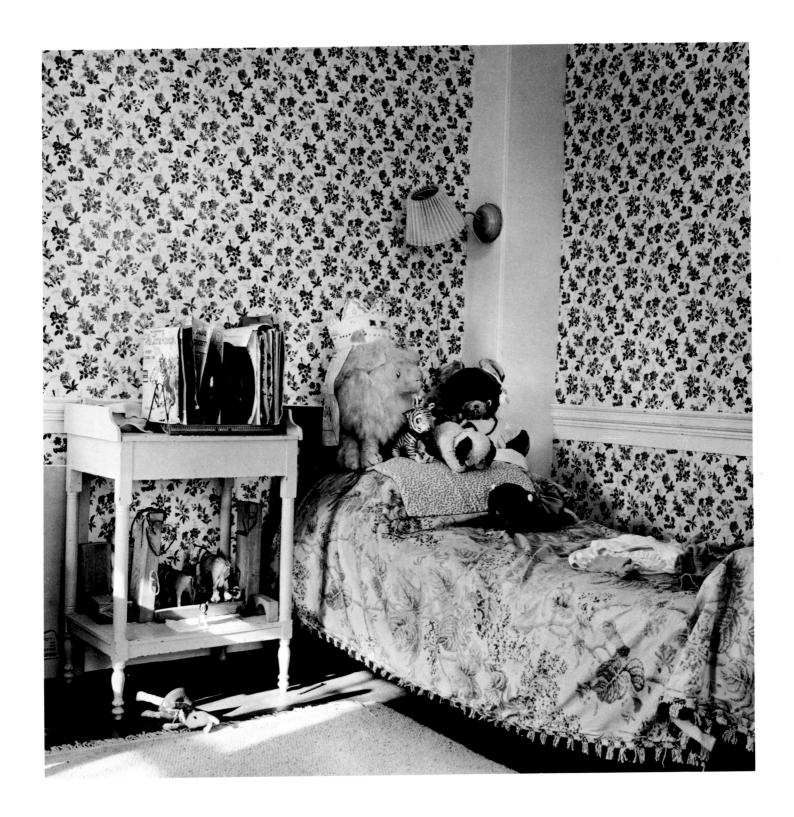

169

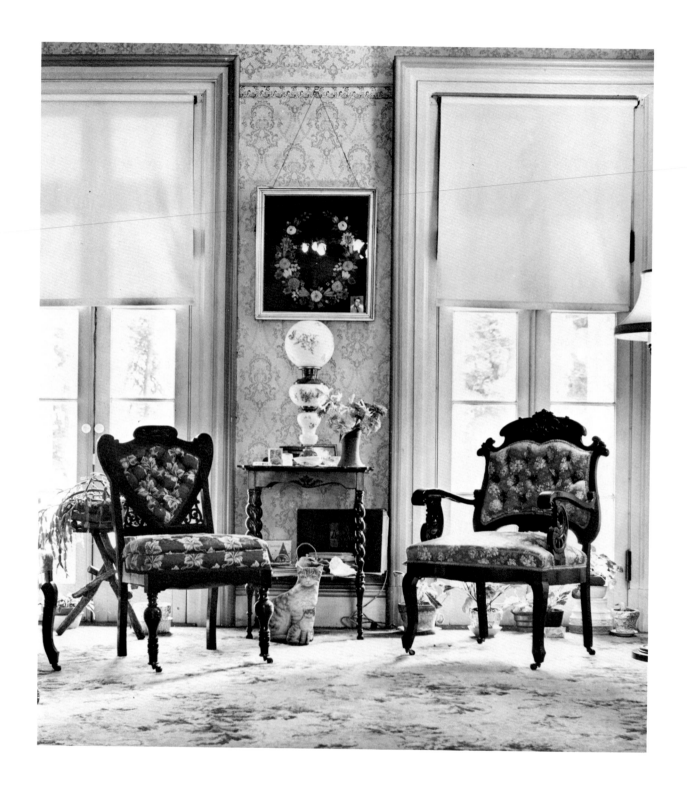

THE PARLOR CHAIRS, OLDWICK, NEW JERSEY, 1958

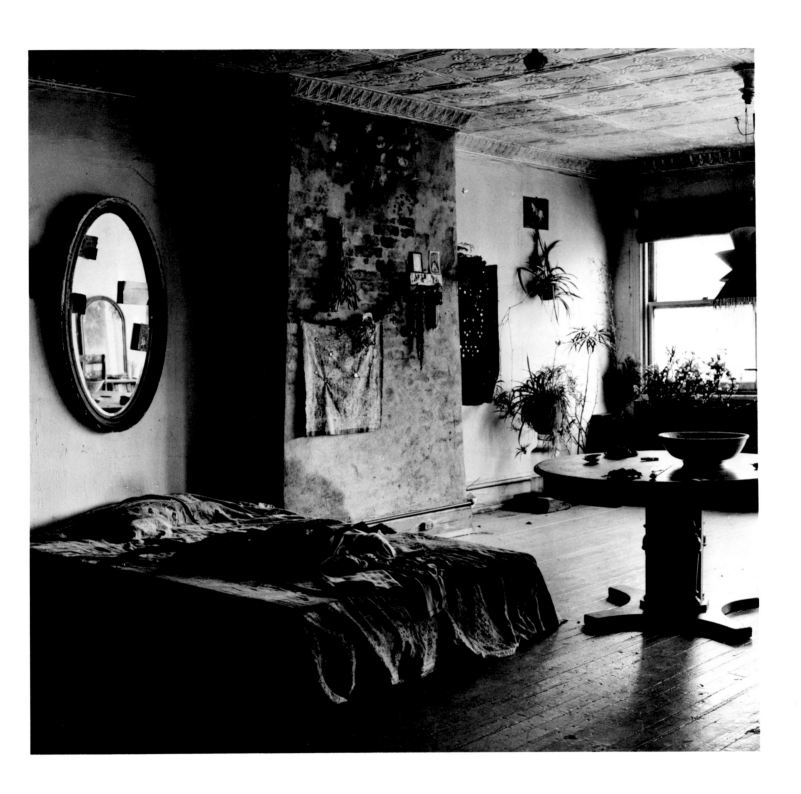

MARY FRANK'S BED, NEW YORK, 1959

THE HOME ORGAN, CHESTER, NOVA SCOTIA, 1968

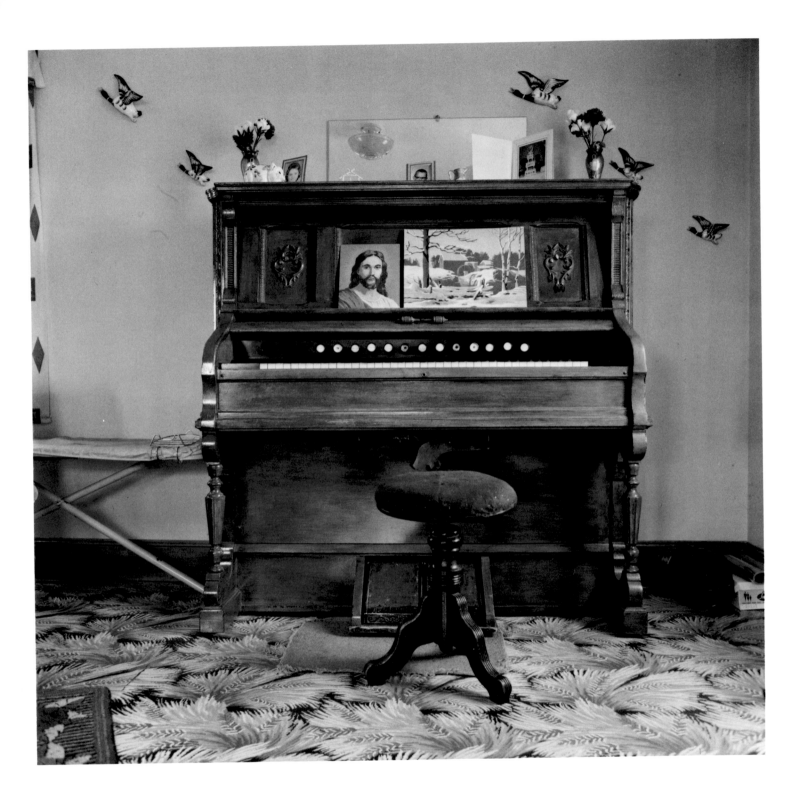

BEDROOM DRESSER, NEWCASTLE, MAINE, CA. 1967

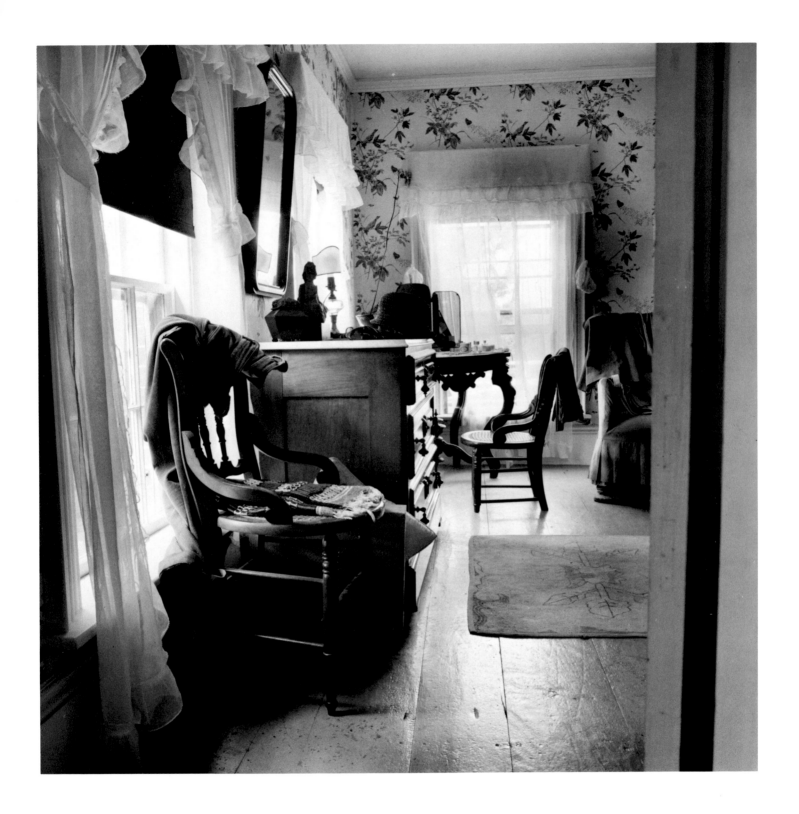

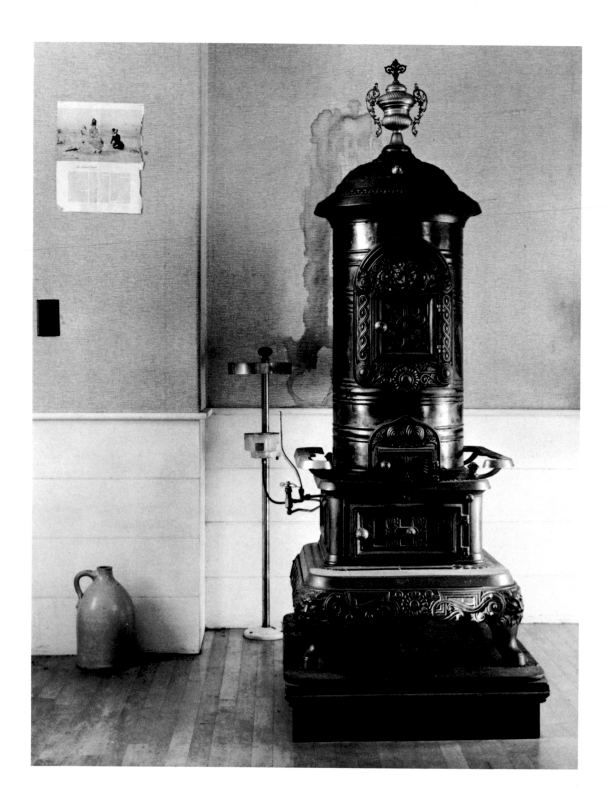

STOVE, HELIKER HOUSE, CRANBERRY ISLAND, MAINE, 1969

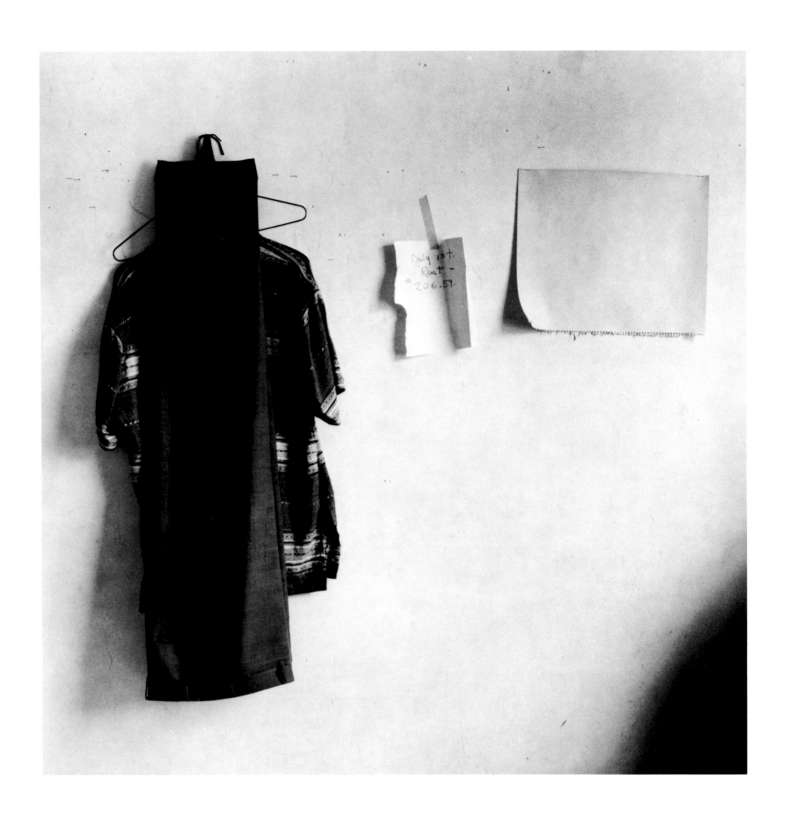

JACK HELIKER'S BEDROOM WALL, CRANBERRY ISLAND, MAINE, 1969 177

Anna Maria Island, Florida, 1968

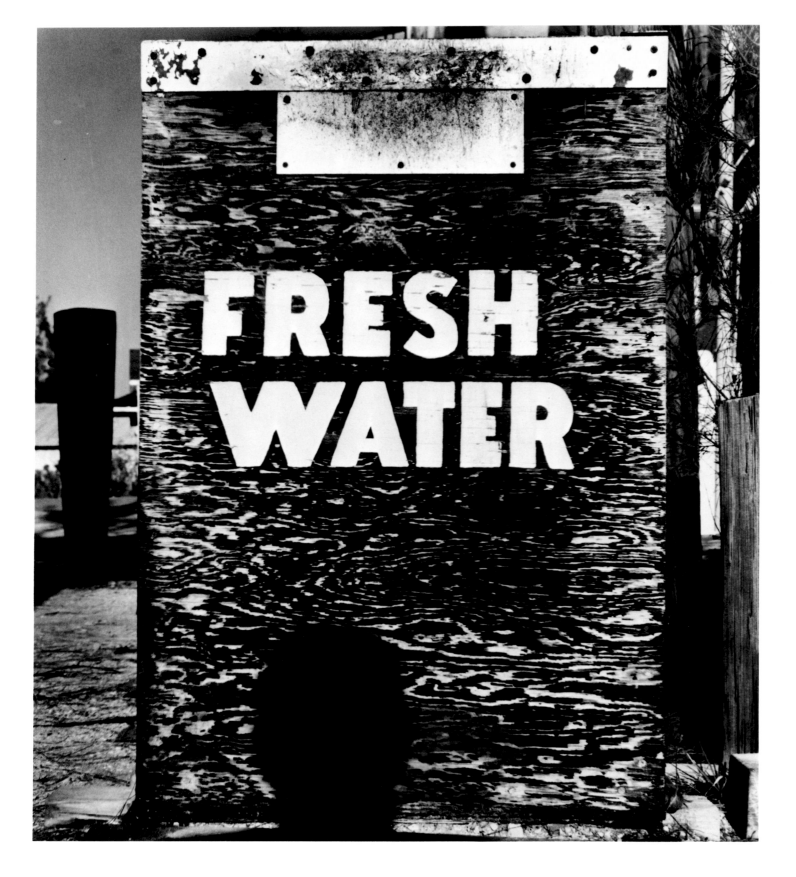

GUTHRIE, KENTUCKY, NEW YEAR'S DAY, 1970

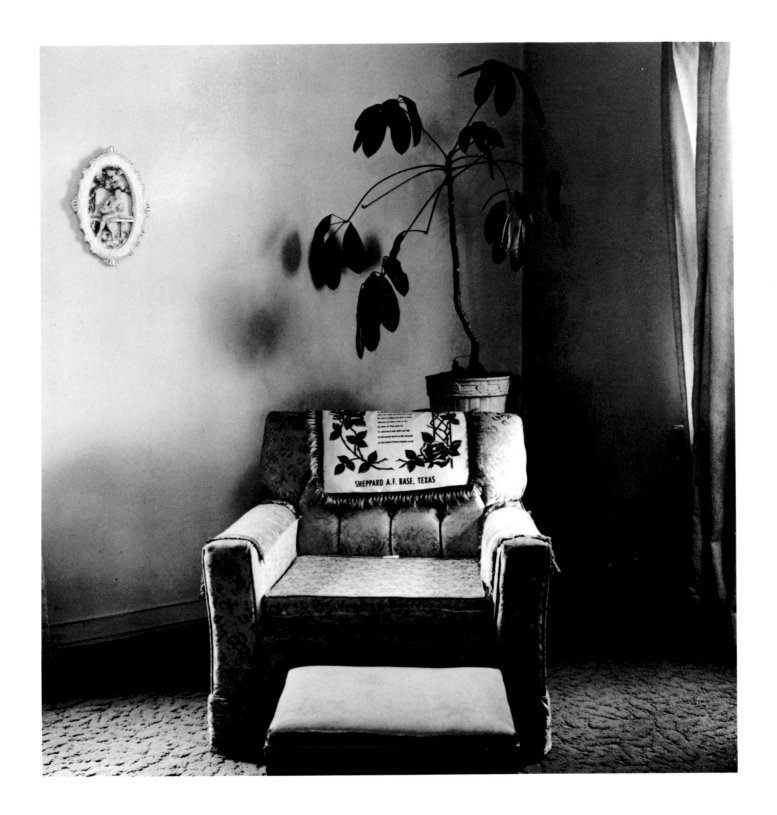

SHEPPARD A.F. BASE, TEXAS

Selected Bibliography

THIS BIBLIOGRAPHY is divided into six categories: Books by or with Walker Evans; Picture Essays and Articles by Evans; Articles, and Reviews of Exhibitions or Books; Film; General Works; and Exhibitions. All entries are listed chronologically in each category.

Anne Tucker Cohn and William Burback

BOOKS BY OR WITH WALKER EVANS

1 Crane, Hart. *The Bridge.* Paris: Black Sun Press, 1930. Limited edition. 3 photographs by Evans.
 The Bridge was also published in 1930 by Liveright (New York), a first edition in April and a second edition in July. The frontispiece in each edition is by Evans; neither duplicates those in the Black Sun edition.

2 Beals, Carleton. *The Crime of Cuba.* Philadelphia and London: J. B. Lippincott, 1933. 31 photographs by Evans.

3 Evans, Walker. *African Negro Art.* A corpus of photographs by Evans prepared by The Museum of Modern Art under a grant from the General Education Board as a record of the exhibition "African Negro Art," directed by James Johnson Sweeney at the Museum, March 18– May 19, 1935. 477 photographs in four bound portfolios (see bibl. 8).

4 Evans, Walker. *American Photographs.* New York: The Museum of Modern Art, 1938. 87 photographs. Essay by Lincoln Kirstein (see bibl. 61, 66, 68, 70–75, 84, and 85).
 Reissued in 1962 with foreword by Monroe Wheeler (see bibl. 86–88, 90–92). Each edition published concurrently with exhibitions of the same name at The Museum of Modern Art (see bibl. 112 and 114).

5 Agee, James and Walker Evans. *Let Us Now Praise Famous Men: Three Tenant Families.* Boston: Houghton Mifflin, 1941. 31 photographs (see bibl. 77 and 78). Reissued in 1960 with 62 photographs and a foreword by Walker Evans (see bibl. 45, 85, and 96). Paperback edition, 1966, Ballantine Books, New York.

6 *Wheaton College Photographs.* Norton, Mass.: Wheaton College, 1941. 24 photographs; foreword by J. Edgar Park.

7 Bickel, Karl. *The Mangrove Coast.* New York: Coward-McCann, 1942. 32 photographs.

8 Radin, Paul and James Johnson Sweeney. *African Folktales & Sculpture.* New York: Pantheon Books, 1952. Bollingen series 32. 165 photographs, 113 by Evans. Reissued in 1964 with 187 photographs, 113 by Evans. Reissued in paperback, 1970, Princeton University Press, as two publications: *African Folktales* by Paul Radin; *African Sculpture* by James Johnson Sweeney with 187 photographs (see bibl. 3).

9 Evans, Walker. *Many Are Called.* Boston: Houghton

Mifflin, 1966. 89 photographs. Essay by James Agee written in 1940 (see bibl. 34, 50, 98, and 100). Published concurrently with exhibition "Walker Evans' Subway" (bibl. 116).

10 Evans, Walker. *Message from the Interior.* New York: Eakins Press, 1966. 12 photographs. Brief essay by John Szarkowski (see bibl. 98 and 100).

11 "Photography." In *Quality,* edited by Louis Kronenberger. New York: Balance House, 1969, pp. 169–211. Essay on photography, with photographs selected by Evans.

Picture Essays and Articles by Evans

12 "Photographic Studies." *Architectural Record* (New York). Vol. 68, September 1930, pp. 193–198. 5 photographs.

13 "Mr. Walker Evans Records a City's Scene." *Creative Art* (New York). Vol. 7, December 1930, pp. 453–456. Brief unsigned text; 4 photographs.

14 "New York City." *Hound & Horn* (Concord, N.H.). Vol. 5, October–December 1930, between pp. 42–43. 4 photographs.

15 "The Reappearance of Photography." *Hound & Horn* (Concord, N.H.). Vol. 5, October–December 1931, pp. 125–128. Review of 6 books.

16 "Cuba Libre." *Hound & Horn* (Concord, N.H.) Vol. 7, July–September 1934, between pp. 586–587. 3 photographs.

17 "Criticisms of Edwin Denby." *Dance Index* (New York). Vol. 5, February 1946, pp. 25–56. 9 photographs on ballet.

18 Evans, Walker and Wilder Hobson. "Homes of Americans." *Fortune* (New York). Vol. 33, April 1946, pp. 148–157. 33 photographs, 7 by Evans, of architecture and architectural details selected by Evans from his own and other collections.

19 "Labor Anonymous." *Fortune* (New York). Vol. 34, November 1946, pp. 152–153. 11 photographs and text on workers in Detroit.

20 "Chicago." *Fortune* (New York). Vol. 35, February 1947, pp. 112–120. 20 photographs and text.

21 "Is the Market Right?" *Fortune* (New York). Vol. 37, March 1948, pp. 77–83. 9 photographs of Wall Street district.

22 "Main Street Looking North from Courthouse Square." *Fortune* (New York). Vol. 37, May 1948, pp. 102–106. 18 color postcards selected by Evans from his own and other collections; text by Evans.

23 "In the Heart of the Black Belt." *Fortune* (New York). Vol. 38, August 1948, pp. 88–89. Text by Evans on the painter Jacob Lawrence.

24 "Summer North of Boston." *Fortune* (New York). Vol. 40, August 1949, pp. 74–79. 6 photographs (color and black-and-white) and text on New England resort hotels.

25 "Along the Right of Way." *Fortune* (New York). Vol. 42, September 1950, pp. 106–113. 7 photographs (color and black-and-white) and text on American landscapes seen through a train window.

26 "The Wreckers." *Fortune* (New York). Vol. 43, May 1951, pp. 102–105. 7 photographs (color and black-and-white) and text on the ceremony of tearing down a house.

27 "Imperial Washington." *Fortune* (New York). Vol. 45, February 1952, pp. 94–99. 13 photographs (color and black-and-white) and text on Washington, D.C.

28 "The U.S. Depot." *Fortune* (New York). Vol. 47, February 1953, pp. 138–143. 5 photographs (color and black-and-white) and text on railroad stations.

29 "Vintage Office Furniture." *Fortune* (New York). Vol. 48, August 1953, pp. 123–127. 5 photographs and text.

30 "Over California." *Fortune* (New York). Vol. 49. March 1954, pp. 105–112. Text by Evans; photographs by William A. Garnett.

31 "October's Game." *Fortune* (New York). Vol. 50, October 1954, pp. 132–137. 10 color photographs and text on golf.

32 "Beauties of the Common Tool." *Fortune* (New York). Vol. 52, July 1955, pp. 103–107. 5 photographs and text.

33 "The Congressional." *Fortune* (New York). Vol. 52, November 1955, pp. 118–122. Text by Evans; 10 photographs by Robert Frank on the New York-to-Washington commuter train.

34 "Rapid Transit." *The Cambridge Review* (Cambridge,

Mass.). No. 5, March 1956, pp. 16–25. 8 photographs by Evans and essay by James Agee; both later published in *Many Are Called* (bibl. 9).

35 "These Dark Satanic Mills." *Fortune* (New York). Vol. 53, April 1956, pp. 139–146. 10 color photographs and text on Early American river mills.

36 "Downtown, a Last Look Backward." *Fortune* (New York). Vol. 54, October 1956, pp. 157–162. 9 photographs and text on New York financial district.

37 "Before They Disappear." *Fortune* (New York). Vol. 55, March 1957, pp. 141–145. 13 color photographs and text on freight-car emblems.

38 "The Stones of duPont." *Fortune* (New York). Vol. 55, May 1957, pp. 167–170. 6 color photographs and text on 19th-century water mills.

39 "Color Accidents." *Architectural Forum* (New York). Vol. 108, January 1958, pp. 110–115. 7 color photographs of aged and defaced walls and doors.

40 "The London Look." *Architectural Forum* (New York). Vol. 108, April 1958, pp. 114–119. 10 photographs.

41 "The Last of Railroad Steam." *Fortune* (New York). Vol. 58, September 1958, pp. 137–141. 6 photographs and text on locomotives.

42 "The Pitch Direct." *Fortune* (New York). Vol. 58, October 1958, pp. 139–143. 6 color photographs and text on sidewalk markets in New York.

43 "And That Is That." *Fortune* (New York). Vol. 58, December 1958, pp. 85–88. 7 photographs on antique Rolls Royce cars.

44 "Robert Frank." *U.S. Camera Annual 1958,* New York: U.S. Camera Publishing Corp., 1958, p. 90. Statement by Evans, with a statement and photographs by Frank.

45 "James Agee in 1936." *Atlantic* (Boston). Vol. 206, July 1960, pp. 74–75. Evans' memoir of Agee, included in 1960 edition of *Let Us Now Praise Famous Men* (bibl. 5).

46 "On the Waterfront." *Fortune* (New York). Vol. 62, November 1960, pp. 145–150. 10 color photographs and text on Port of New York warehouses.

47 "People and Places in Trouble." *Fortune* (New York). Vol. 63, March 1961, pp. 110–117. 9 photographs and text on unemployment.

48 "Primitive Churches." *Architectural Forum* (New York). Vol. 115, December 1961, pp. 102–107. 7 photographs and text on out-of-the-way churches.

49 "When 'Downtown' Was a Beautiful Mess." *Fortune* (New York). Vol. 65, January 1962, pp. 101–106. Text by Evans. 8 color postcards from Evans' collection.

50 "Walker Evans: The Unposed Portrait." *Harper's Bazaar* (New York). Vol. 95, March 1962, pp. 120–125. 8 photographs from subway series (bibl. 9 and 116) and text.

51 "The American Warehouse." *Architectural Forum* (New York). Vol. 116, April 1962, pp. 94–98. 4 photographs and brief text.

52 "The Auto Junk Yard." *Fortune* (New York). Vol. 65, April 1962, pp. 132–137. 8 color photographs and text.

53 "Come On Down." *Architectural Forum* (New York). Vol. 117, July 1962, pp. 96–100. 7 postcards from Evans' collection and brief text by Evans.

54 "Those Little Screens." *Harper's Bazaar* (New York). Vol. 96, February 1963, pp. 126–129. Text by Evans; photographs of television sets by Lee Friedlander.

55 "A Heritage Must Be Saved." *Life* (New York). Vol. 55, July 5, 1963, pp. 52–60. 13 photographs on historical landmarks.

56 "Amerikanische Architekturgestern: 12 Schwarzweiss-aufnahmen." *Du* (Zurich). Vol. 24, June 24, 1964, pp. 2–16. Portfolio of photographs by Evans, text by W.R.

57 "American Masonry." *Fortune* (New York). Vol. 71, April 1965, pp. 150–153. 7 color photographs and text.

ARTICLES, AND REVIEWS OF EXHIBITIONS OR BOOKS

58 Knowlton, Walter. "Around the Galleries." *Creative Art* (New York). Vol. 8, May 1931, pp. 375–376. Review of "Photographs by 3 Americans" (bibl. 120).

59 Wright, Frank Lloyd. "Tyranny of the Skyscraper." *Creative Art* (New York). Vol. 8, May 1931, pp. 324–332. 4 photographs, 2 by Evans, from "Photographs by 3 Americans" (bibl. 120).

60 Newhall, Beaumont. "Documentary Approach to Photography." *Parnassus* (New York). Vol. 10, March 1938, pp. 2–6.

61 "American Photographs." *U.S. Camera* (New York). Vol. 1, Autumn 1938, pp. 47, 64. Review of *American Photographs* (bibl. 4) with reply by Glenway Wescott.

62 McCausland, Elizabeth. "Rural Life in America as the Camera Shows It." *Springfield Republican* (Springfield, Mass.). September 11, 1938. Review of "American Photographs" (bibl. 112) and a circulating exhibition "Documents of America: The Rural Scene."

63 D[avidson], M[artha]. "Evans' Brilliant Camera Records of Modern America." *Art News* (New York). Vol. 37, October 8, 1938, pp. 12–13. Review of "American Photographs" (bibl. 112).

64 Jewell, Edward Alden. "Camera: Aspects of America in Three Shows." *New York Times.* Vol. 88, October 2, 1938, Section 9, p. X9. Review of "American Photographs" (bibl. 112), John Albok at the Museum of the City of New York, and WPA at the Federal Gallery.

65 "Recorded Time." *Time* (New York). Vol. 32, October 3, 1938, p. 43. 1 photograph. Review of "American Photographs" (bibl. 112).

66 Williams, William Carlos. "Sermon with a Camera." *New Republic* (New York). Vol. 96, October 12, 1938, p. 282. Review of *American Photographs* (bibl. 4).

67 Rogers, John William. "Odd Photographs on Exhibition in New York Museum." *Times-Herald* (Dallas, Tex.). October 30, 1938. 4 photographs. Review of "American Photographs" (bibl. 112).

68 Seitlin, Percy. "Book Reviews." *PM* (New York). Vol. 4, October–November 1938, pp. 77–79. 3 photographs. Review of *American Photographs* (bibl. 4).

69 Reily, Rosa. "Photographing the America of Today." *Popular Photography* (New York). Vol. 3, November 1938, pp. 10–11, 76–77. Interview with Roy Stryker, illustrated with 4 photographs, 2 by Evans.

70 Mabry, Thomas Dabney. "Walker Evans's Photographs of America." *Harper's Bazaar* (New York). November 1, 1938, pp. 84–85, 140. 3 photographs. Review of *American Photographs* (bibl. 4), exhibition (bibl. 112).

71 Williamson, S. T. "American Photographs by Walker Evans." *New York Times.* November 27, 1938, book review section, p. 6. Review of *American Photographs* (bibl. 4).

72 Whiting, F. A., Jr. "Walker Evans." *Magazine of Art* (Washington, D.C.). Vol. 31, December 1938, pp. 721–722. 1 photograph. Review of *American Photographs* (bibl. 4).

73 Seldes, Gilbert. "No Soul in the Photographs." *Esquire* (Chicago). Vol. 10, December 1, 1938, pp. 121, 242–243. Review of *American Photographs* (bibl. 4).

74 Lorentz, Pare. "Putting America on Record." *Saturday Review of Literature* (New York). Vol. 19, December 17, 1938, p. 6. Review of *American Photographs* (bibl. 4), *Photography and the American Scene* by Robert Taft, and *U.S. Camera Annual 1939,* edited by Edward Steichen.

75 West, Anthony. "Middletown and Main Street." *Architectural Review* (London). Vol. 85, May 1939, pp. 218–220. 9 photographs from *American Photographs* (bibl. 4) discussed as illustrations to article.

76 Steichen, Edward. "The FSA Photographers." *U.S. Camera Annual 1939,* New York: William Morrow, 1938, pp. 43–66. 41 photographs, 3 by Evans (see bibl. 126).

77 Rodman, Selden. "The Poetry of Poverty." *Saturday Review of Literature* (New York). Vol. 24, August 23, 1941, p. 6. Review of *Let Us Now Praise Famous Men* (bibl. 5).

78 Lechletner, Ruth. "Alabama Tenant Families." *New York Herald Tribune,* August 24, 1941, Section 9, p. 10. Review of *Let Us Now Praise Famous Men* (bibl. 5).

79 Stryker, Roy E. "Documentary Photography." *The Complete Photographer* (New York). Vol. 4, April 10, 1942, pp. 1364–1374. 20 photographs, 2 by Evans.

80 "Puritan Explorer." *Time* (New York). Vol. 50, December 15, 1947, p. 73. 1 photograph. Review of retrospective at The Art Institute of Chicago (bibl. 113).

81 "Walker Evans: Corner of State and Randolph Streets, Chicago." *U.S. Camera Annual 1949,* New York: U.S. Camera Publishing Corp., 1948, pp. 12–13, 6 photographs.

82 Soby, James Thrall. "Walker Evans." *Saturday Review of Literature* (New York). Vol. 39, February 18, 1956, pp. 28–29. Review of "Diogenes with a Camera III" (bibl. 128) and personal remembrances of Evans (see also revised accounts, bibl. 83 and 88).

83 "Four Photographers." In James Thrall Soby, *Modern Art and the New Past*. Norman, Okla.: University of Oklahoma Press, 1957, pp. 158–177. Essay on Evans, Alfred Stieglitz, Paul Strand, and Henri Cartier-Bresson (see bibl. 82 and 88).

84 Kirstein, Lincoln. "Photographs by Walker Evans." *Print* (New York). Vol. 11, February 1957, pp. 56–57. 2 photographs. Excerpt from Kirstein's essay in *American Photographs* (bibl. 4).

85 Smith, Henry Holmes. "Concerning Significant Books." *Aperture* (Rochester, N.Y.). Vol. 8, no. 4, 1960, pp. 188–192. Review of reissue of *Let Us Now Praise Famous Men* (bibl. 5) with comment on *American Photographs* (bibl. 4).

86 Deschin, Jacob. "Portrait of an Era." *New York Times*, June 10, 1962, p. 12. 1 photograph. Review of reissue of *American Photographs* (bibl. 4).

87 Weiss, Margot. "Book Review." *Infinity* (New York). Vol. 11, September 1962, p. 13. Review of reissue of *American Photographs* (bibl. 4) and Robert Frank's *The Americans* (see also bibl. 44).

88 Soby, James Thrall. "The Muse Was Not for Hire." *Saturday Review* (New York). Vol. 45, September 22, 1962, pp. 57–58. 2 photographs. Review of reissue of *American Photographs* (bibl. 4) including personal remembrances of Evans (see also bibl. 82 and 83).

89 Doherty, Robert J., Jr. "USA FSA, Farm Security Administration Photographs of the Depression Era." *Camera* (Lucerne). Vol. 41, October 19, 1962, pp. 9–51. Photographs by each FSA photographer, 5 by Evans.

90 Herbst, Josephine. "The Daybooks of Edward Weston; Walker Evans: American Photographs." *Arts Magazine* (New York). Vol. 37, November 1962, pp. 62–64. 2 photographs, 1 by Evans. Review (see bibl. 4).

91 Massar, Phyllis Dearborn. *Progressive Architecture* (New York). Vol. 43, November 1962, pp. 188–189. Review of reissue of *American Photographs* (bibl. 4).

92 Elliott, George P. "Things of This World." *Commentary* (New York). Vol. 34, December 1962, pp. 540–543. Review of reissue of *American Photographs* (bibl. 4).

93 "Photographs and Photographers." In George P. Elliott, *A Piece of Lettuce*. New York: Random House, 1964, pp. 90–103. Essay on Evans, Henri Cartier-Bresson, Dorothea Lange, and Edward Weston.

94 Severin, Werner J. "Cameras with a Purpose: The Photojournalists of FSA." *Journalism Quarterly* (University of Minnesota), Vol. 41, Spring 1964, pp. 191–200.

95 Wolfe, C. "Review of Exhibition." *Arts & Architecture* (Los Angeles). Vol. 81, August 1964, pp. 6–7. 34 photographs, none by Evans. Review of "The Bitter Years" (see bibl. 108 and 129).

96 "What Agee Found in Alabama in 1936." *The Times* (London), July 15, 1965, Literary Supplement, p. 598. 1 photograph. Review of reissue of *Let Us Now Praise Famous Men* (bibl. 5).

97 "John Simon Guggenheim Memorial Foundation Fellows in Photography 1937–65." *Camera* (Lucerne). Vol. 45, April 1966, pp. 12–13. Photographs by each Fellow, 2 by Evans (see bibl. 131).

98 "Art of Seeing." *The New Yorker* (New York). Vol. 42, December 24, 1966, pp. 26–27. Review of *Many Are Called* (bibl. 9), *Message from the Interior* (bibl. 10), and exhibition at Schoelkopf Gallery (bibl. 117).

99 Wallace, George. "Exhibition at Norman Mackenzie Art Gallery." *Arts Canada* (Toronto), January 24, 1967, Supplement, p. 5. Review of "American Photographs," circulated by the National Gallery of Canada (bibl. 114).

100 Tillim, Sidney. "Walker Evans: Photography as Representation." *Artforum* (New York). Vol. 5, March 1967, pp. 14–18. 8 photographs. Review of *Many Are Called* (bibl. 9), *Message from the Interior* (bibl. 10), and exhibition at Schoelkopf Gallery (bibl. 117).

101 Sylvester, David. "Walker Evans: A World of Stillness and Silence." *The Sunday Times Magazine* (London), March 31, 1968, pp. 36–41. 8 photographs; also a brief essay.

Film

102 Pakay, Sedat. "Walker Evans: His Time, His Presence, His Silence." 1969. 16mm, 22 min. Distributed by Film Images, New York.

GENERAL WORKS

103 Newhall, Beaumont. *Photography: A Short Critical History.* New York: The Museum of Modern Art, 1938. Expanded version of exhibition catalogue (bibl. 125; see also bibl. 109).

104 *Art In Our Time.* Edited by Alfred H. Barr, Jr. New York: The Museum of Modern Art, 1939. Catalogue of exhibition (bibl. 127). Photography section, "Seven American Photographers," with introduction by Beaumont Newhall, pp. 271–288.

105 Anderson, Sherwood. *Home Town.* New York: Alliance Book Corporation, 1940. 142 photographs by the Farm Security Administration photographers, 7 by Evans.

106 Rodman, Selden. *Portrait of the Artist as an American. Ben Shahn: A Biography with Pictures.* New York: Harper & Brothers, 1951, pp. 89–90, 125–126. Biographical sketches of Evans' and Shahn's friendship.

107 *Masters of Photography.* Edited by Beaumont and Nancy Newhall. New York: Bonanza Books, 1958.

108 *The Bitter Years 1934–41: Rural America as Seen by the Photographers of the Farm Security Administration.* Edited by Edward Steichen, with an introduction by Grace M. Mayer. New York: The Museum of Modern Art, 1962. Issued in conjunction with the exhibition (bibl. 129; see also bibl. 95).

109 Newhall, Beaumont. *The History of Photography.* New York: The Museum of Modern Art, 1964.

110 *Just Before the War.* Edited by Thomas H. Garver. Balboa, Calif.: Newport Harbor Art Museum, 1968. Issued in conjunction with exhibition (bibl. 132).

EXHIBITIONS

One-Man Exhibitions

111 "Walker Evans: Photographs of 19th Century Houses." New York, The Museum of Modern Art, November 16–December 8, 1933. Directed by Lincoln Kirstein.

112 "Walker Evans: American Photographs." New York, The Museum of Modern Art, September 28–November 18, 1938; subsequently circulated. 100 photographs (see bibl. 62–65, 67, and 70; see also bibl. 4).

113 "Walker Evans Retrospective." Chicago, The Art Institute of Chicago, November 14–January 4, 1948. Organized by Carl O. Schniewind and Thomas Dabney Mabry. 75 photographs (see bibl. 80).

114 "Walker Evans: American Photographs." New York, The Museum of Modern Art, June 8–August 14, 1962. 28 photographs selected from 1938 exhibition (bibl. 112); circulated by The Museum of Modern Art, 1963–65, and by the National Gallery of Canada, 1966 (see bibl. 99; see also bibl. 4).

115 "Walker Evans." Chicago, The Art Institute of Chicago, November 13, 1964–January 10, 1965. Directed by Hugh Edwards. 60 photographs, including work done for the Container Corporation of America, previously unexhibited photographs of the 1930s, and photographs taken on Chicago's South Side.

116 "Walker Evans' Subway." New York, The Museum of Modern Art, October 5–December 11, 1966. Directed by John Szarkowski. 41 photographs taken in the New York City subways, 1938–41 (see also bibl. 9, 34, and 50).

117 "Walker Evans." New York, Robert Schoelkopf Gallery, December 20, 1966–January 7, 1967. 40 photographs (see bibl. 98 and 100).

118 "Walker Evans: Paintings and Photographs." New York, The Century Association, February 25–April 5, 1970. Organized by A. Hyatt Mayor. 9 paintings and 45 photographs.

Group Exhibitions

119 "International Photography." Cambridge, Mass., Harvard Society for Contemporary Art, November 7–29, 1930. Organized by Lincoln Kirstein. Included work of 17 photographers, 10 photographs by Evans. Checklist.

120 "Photographs by 3 Americans." New York, John Becker Gallery, April 18–May 8, 1931. Included Evans, Margaret Bourke-White, and Ralph Steiner. Exhibition announcement introduction by M. F. Agha (see bibl. 58 and 59).

121 "Walker Evans and George Platt Lynes." New York, Julien Levy Gallery, February 1–19, 1932.

122 "Modern Photography at Home and Abroad." Buffalo,

Albright Art Gallery, February 7–25, 1932. Included 27 photographers, 7 photographs by Evans. Checklist.

123 "International Photographers." Brooklyn, N.Y., Brooklyn Museum, March 8–31, 1932. Included 39 photographers, 12 photographs by Evans. Checklist.

124 "Documentary and Anti-Graphic: Photographs by Cartier-Bresson, Evans and Alvarez Bravo." New York, Julien Levy Gallery, April 23–May 7, 1935.

125 "Photography 1839–1937." New York, The Museum of Modern Art, March 17–April 18, 1937. Directed by Beaumont Newhall. Included 132 photographers, 6 photographs by Evans (see bibl. 103).

126 "First International Photographic Exposition." New York, Grand Central Palace, April 18–29, 1938. Exhibition of FSA photographers (see bibl. 76).

127 "Art in Our Time," New York, The Museum of Modern Art, May 10–September 30, 1939. Tenth Anniversary Exhibition. Photography section, "Seven American Photographers," directed by Beaumont Newhall. Included Evans, Berenice Abbott, Ansel Adams, Dr. Harold Edgerton, Man Ray, Ralph Steiner, and Edward Weston, 7 photographs by Evans (see bibl. 104).

128 "Diogenes with a Camera III." New York, The Museum of Modern Art, January 17–March 18, 1956. Directed by Edward Steichen. Included Evans, Alvarez Bravo, August Sander, and Paul Strand, 9 photographs by Evans (see bibl. 82).

129 "The Bitter Years 1935–41." New York, The Museum of Modern Art, October 18–November 25, 1962; subsequently circulated. Directed by Edward Steichen. Included 12 photographers, 15 photographs by Evans (see bibl. 95 and 108).

130 "Contemporary Art at Yale: 1." New Haven, Conn., Yale University Art Gallery, January 13–February 15, 1965. Included work of three faculty members: Evans, Norman Ives, and Lester Johnson, 25 photographs by Evans. [Evans appointed Professor of Graphic Design in 1964.]

131 "The John Simon Guggenheim Memorial Foundation Fellows in Photography." Philadelphia, Philadelphia College of Art, April 15–May 13, 1966; subsequently circulated. Directed by Sol Mednick. Included 30 photographers (see bibl. 97). [Evans received Guggenheim fellowships in 1940–41 and 1959.]

132 "Just Before the War." Balboa, Calif., Newport Harbor Art Museum, September 30–November 10, 1968; subsequently circulated. Directed by Thomas Garver. Included 15 photographers, 19 photographs by Evans (see bibl. 110).